Rocky Mountains
Wilderness Reflections

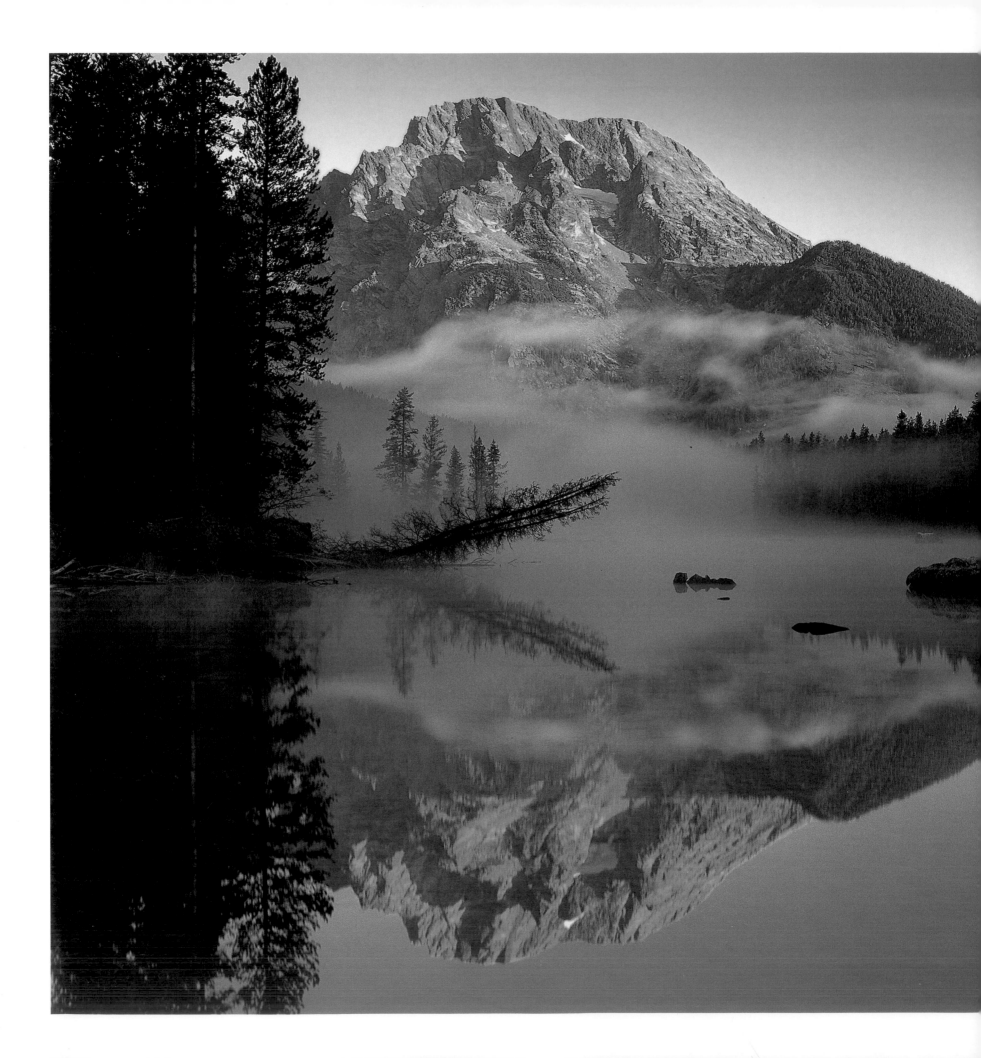

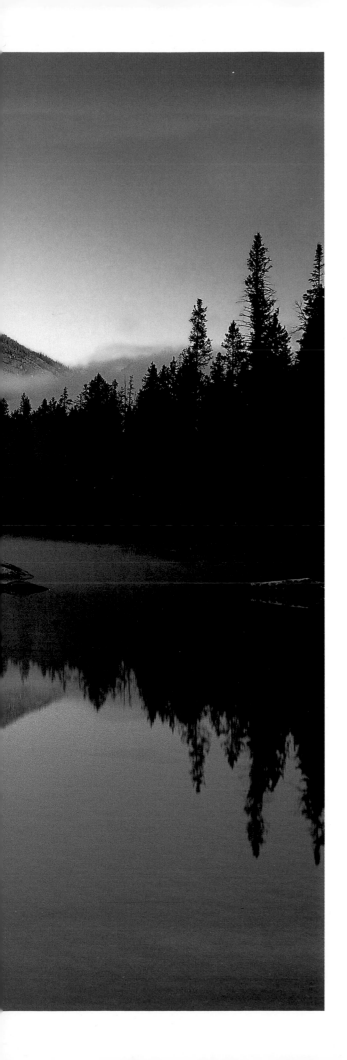

Rocky Mountains
Wilderness Reflections

Text and Photographs by
Tim Fitzharris

FIREFLY BOOKS

A FIREFLY BOOK

Published by Firefly Books Ltd., 2000

First Printing

Canadian Cataloguing in Publication Data

Fitzharris, Tim 1948–
 Rocky Mountains : wilderness reflections
ISBN 1-55209-387-5
1. Natural History – Rocky Mountains – Pictorial works. 2. Rocky Mountains – Pictorial works.I.Title.
QH104.5.R6F57 2000 508.78 C99-931664-8

U.S. Cataloging-in-Publication Data

Fitzharris, Tim, 1948 –
 Rocky Mountains : wilderness reflections / by Tim Fitzharris.—1st ed.
[144] p. : col. ill. (maps); cm.
Includes glossary and index.

ISBN 1-55209-387-5
1. Rocky Mountains Region – Pictorial works. 2. Canadian Rockies (B.C. and Alta.) – Pictorial works.
3. Natural history – Rocky Mountains Region – Pictorial works. ll. Title.
799/ .9978–dc21 2000 CIP

Published in Canada in 2000 by
Firefly Books Ltd.
3680 Victoria Park Avenue
Willowdale, Ontario
Canada M2H 3K1

Published in the United States in 2000 by
Firefly Books (U.S.) Inc.
P.O. Box 1338, Ellicott Station
Buffalo, New York
USA 14205

Produced by Terrapin Books
Project Manager: Joy Fitzharris
Design: Klaus Tyne
Research: Jocelyn Delan

Author photos by Joy Fitzharris

Printed in Hong Kong

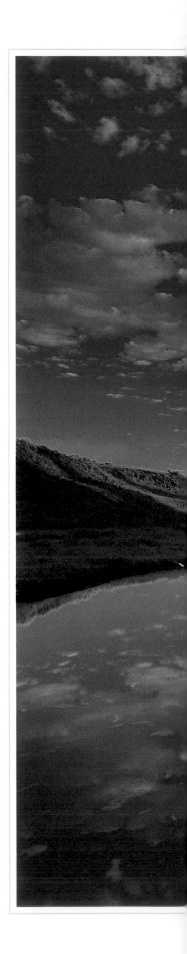

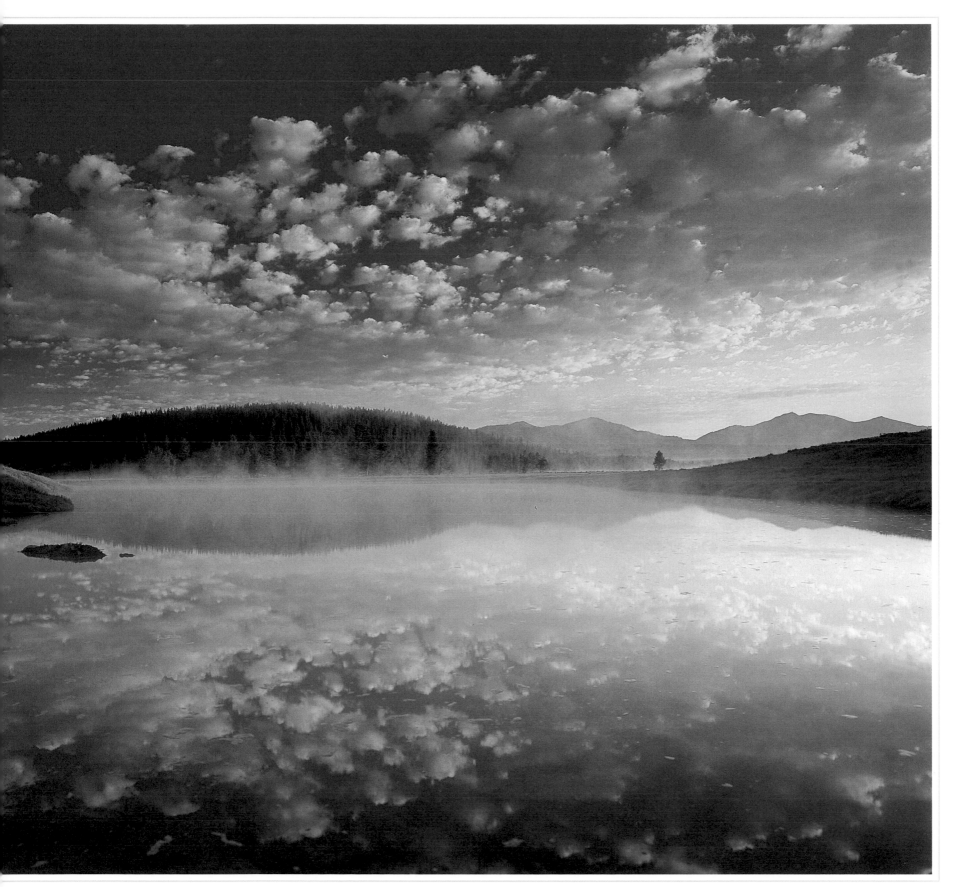

Alum Creek and Absaroka Range, Yellowstone National Park, Wyoming. Preceding pages: Mount Moran, Grand Teton National Park, Wyoming.

For Mark and Shannon

Other Books by Tim Fitzharris

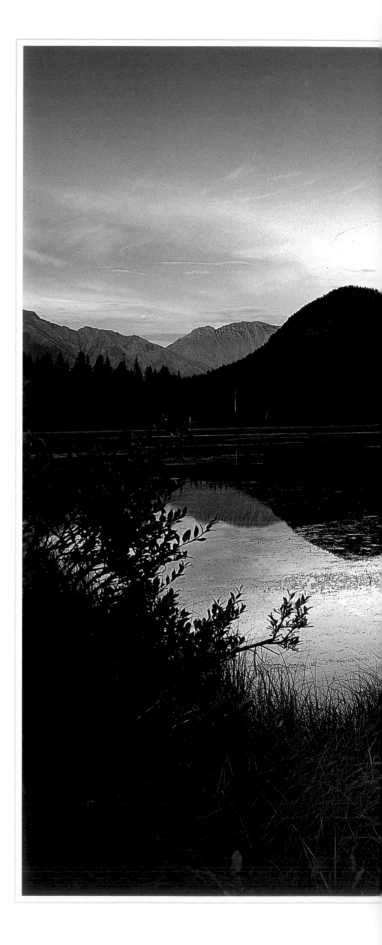

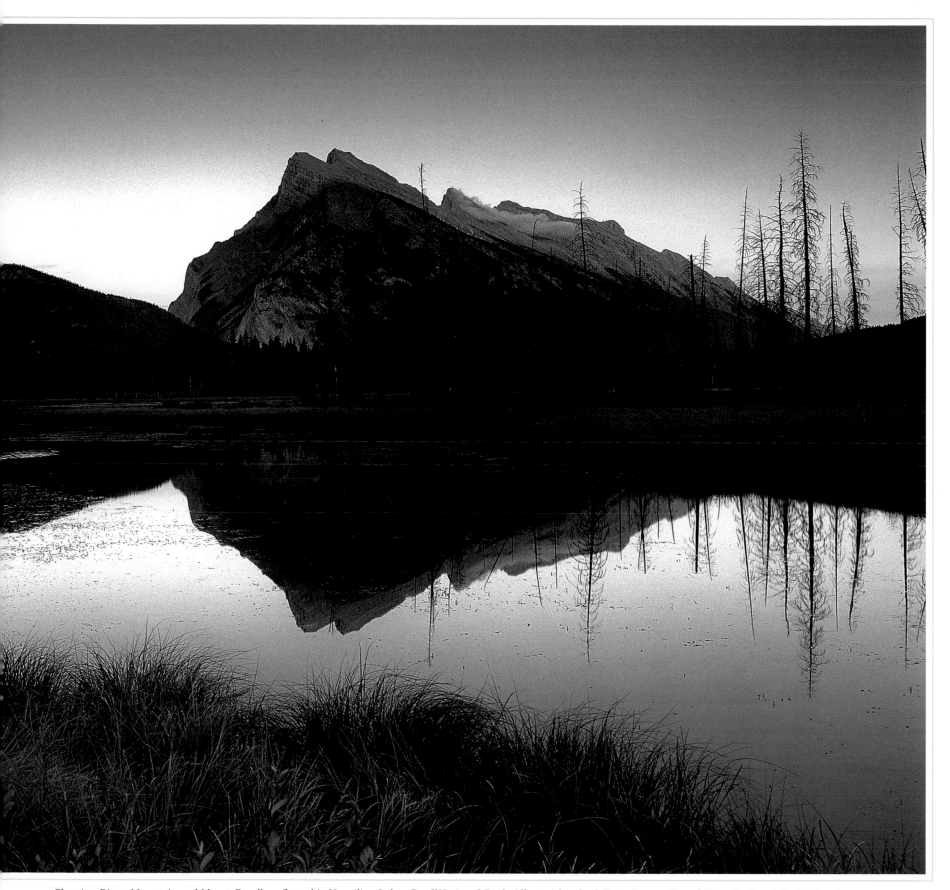

Sleeping Bison Mountain and Mount Rundle reflected in Vermilion Lakes, Banff National Park, Alberta. Overleaf: Teton Range, Grand Teton National Park, Wyoming.

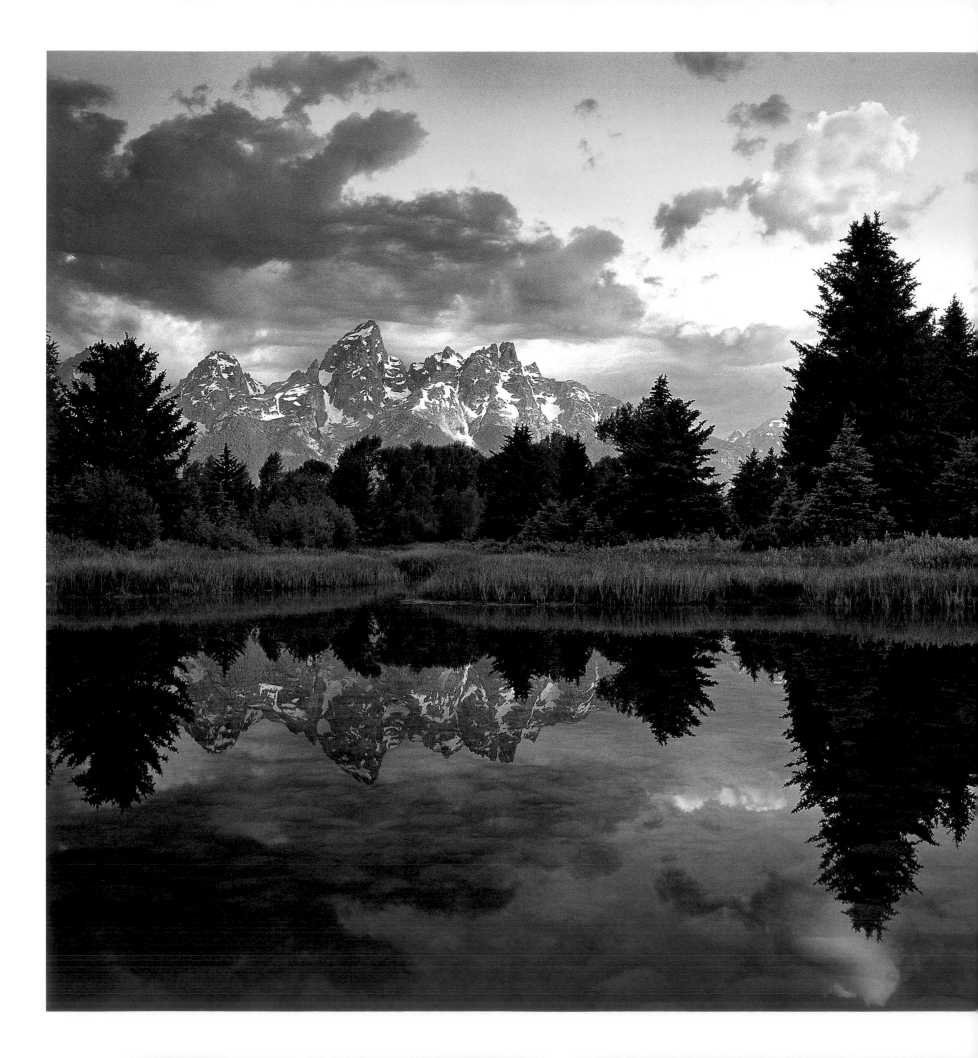

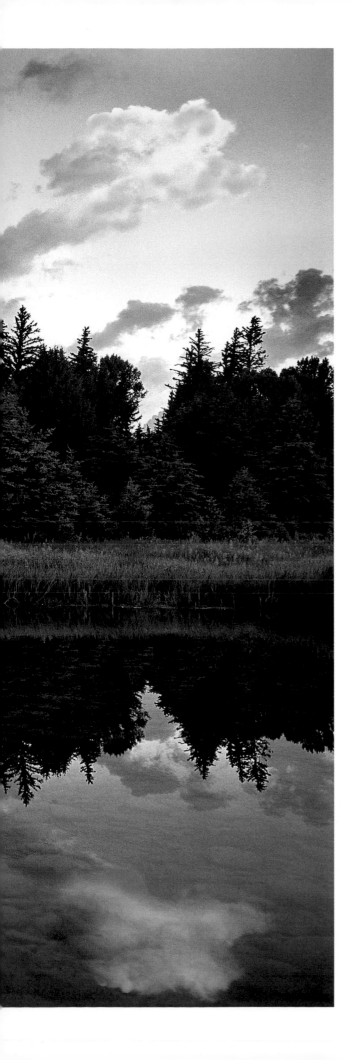

Contents

Rocky Mountain Region

Cassiar Mts

Rocky Mountain Trench

Omineca Mts

Stone Mountain PP

Cariboo Mts

Mount Robson PP
Jasper NP

Edmonton

Mount Revelstoke NP

Columbia Mts

Banff NP
Calgary
Kananaskis Country

Vancouver

Seattle

Waterton Lakes NP

Spokane Glacier NP

Regina

Helena

Bitterroot Range

Absaroka Range

Sawtooth Range Yellowstone NP

Bighorn Mts

Grand Teton NP

Wind River Mts

San Francisco

Salt Lake City

Cheyenne

Rocky Mountain NP

Front Range

Aspen Denver

Elk Mountains

Sangre de Cristo Range

Los Angeles

San Juan Mountains

Durango Great Sand Dunes NM

Santa Fe

San Andres Mts White Sands NM

Guadalupe Mountains NP

Introduction

An encyclopedia describes the beaver as the architect and builder of the animal world. But I know that he is a photographer like me.

Rising before dawn, I get into the vehicle and cautiously follow a mountain backroad toward my shooting destination. Soon—often I have time for coffee from my thermos—I pull onto the road's shoulder. Below looms a murky chasm into which I will descend. I have been here before during daylight hours to measure the angles and proportions of the view, to take sightings on the looming spires of extruded granite or Navajo sandstone, to gauge the texture of an aspen wood or the freshness of a clump of Colorado columbine. I have checked the disposition of the stone monuments against my compass and staked a claim in the darkness, a spot where I will set up my camera to capture the first, intoxicating light of dawn as it streaks across a cliff or shoots its vermilion energy into tumbling pillows of cloud, cloud that I always hope hangs above me, like a gift.

While it is still dark, my task is to get into position. Weighted with photographic equipment and encased in neoprene waders nearly to my armpits, I feel my way over the bank and down through the rocks, my free hand clinging to shrubs for balance and security. I soon reach the river bottom. Here the vegetation is mostly willow. In the northern Rockies, this is a good place to surprise a bear. It has never happened to me but, nevertheless, my hand shifts to the canister of pepper spray that rests in the pouch of my chest waders six inches below my chin. If a bear does come, there will likely be little warning—the willows are thick and grow taller than I am.

My feeling of brotherly affection for the beaver is tempered by irritation for its habit of digging channels across the right-of-way, soggy fissures hidden in the sedges, their sides slippery with mud, too deep to wade through confidently, often too wide to leap over. My direct route adjusts to these obstacles, and I wind slowly through the mist and fading darkness (stumbling occasionally) towards the dam.

The beaver's signature structure, I suspect, is a reflection of its ego. The biggest dams stand higher than a man, stretch for 50 yd. (45 m) and more, and retain thousands of gallons of water. (These belong to beavers that shoot with 4x5's or use lenses the size of stove pipes.) The top of the dam is more often than not my destination—

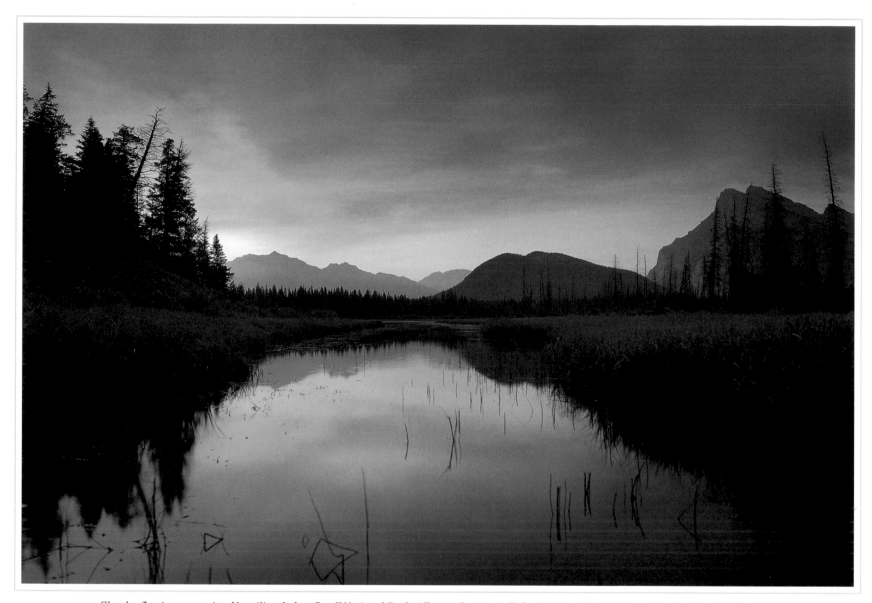

Cloud reflection at sunrise, Vermilion Lakes, Banff National Park, Alberta. Opposite: Sofa Mountain, Waterton Lakes National Park, Alberta.

the place where the tripod will go up. From this elevated vantage point, the stone massif now confronts me above the vegetation while at my feet the silent, fragile surface of the beaver's creation waits for my attention. It is about this time that the artist himself puts in an appearance. *Kah-choink*! and then a few moments later another *kah-choink*! The beaver slaps the perfect expanse with his broad tail and submerges, heading with all speed for the confines of his lodge, sending a tiny tidal wave across the pond. I won't see him again, but his masterpiece slowly comes back into focus, resolving itself in the peace and stillness of dawn.

I stand behind the camera, keenly watching the sky, the peaks in the distance, and, of course, the reflection. Sometimes, tuneful rhythms full of air and power approach and an instant later the silhouette of a curious raven gives fleeting accent to pink and orange reflecting off the

clouds above. In the San Luis Valley of southern Colorado, I might hear the guttural squawk of an egret; in Alberta's Kananaskis Country, it could be the rattle of a snipe or the chip of a flycatcher. The first light flows onto the mountain face and I check its image in the beaver's pond. The emulsion of alpine hues, shapes, and shadows is fine-grained and luminous, a pool of liquid color captured by the beaver in the right place at the right time. The perfect reflection is at once a dream and a confirmation of the solid forms that occupy the horizon. It is the offering of the beaver, an image of wilderness captured through diligence and hard work on a great sheet of film. All is ready for me to record this scene in my camera.

I have now spent most of my life preoccupied with taking pictures, usually in out-of-the-way places, nearly always of scenes made timeless by the absence of humans or human artifacts. The Rocky Mountains comprise one of the last great wilderness areas and I am lucky to live among them. Stretching almost the length of the North American continent, from the Yukon border south into northern Mexico, they rise out of the prairie and desert, dominant and serene. Tickled at their feet by the bustle of people usually bent on industry or recreation, they sustain their austere splendor, their silent soaring bulk a reminder of the smallness and brevity of each of us, a realization that brings simultaneously a sense of immediacy and ease.

I didn't limit my picture-taking to beaver ponds, but trained the camera on anything that threw off a reflection—river backwaters,

lakes, or vernal pools. But I always had a warm sense of artistic companionship when set up on the edge of beaver territory. A delusion of course, the rodent is unaware of the majesty of his accomplishments. Nevertheless, like all fine artists, he enjoys the work. I can imagine him lounging atop the lodge at sunset, legs crossed, small black eyes flitting appreciatively from pond to mountain and from mountain to pond, measuring reality against his personal vision. And, like most photographers, finding them to be a good match.

For this book, I spent much of my time in the field walking about the shores of lakes, rivers, and ponds looking for good camera angles. This is an ideal vantage point from which to appreciate the full range of alpine magnificence. The Rocky Mountain region encompasses the most dramatic landforms on the North American continent. Running in a northwest to southeast direction, these rocky crags, ridges, spires, pinnacles, and pyramids are the result of a single, sustained mountain-building push that lasted 60 million years. As it happened, North America, drifting away from Europe as the Atlantic Ocean expanded, encountered a disintegrating rock mass deep within the earth—the Farillon Plate. This irregularity caused the crust of the continent to tear and crumple, pushing up the mountains we know today as the Rockies.

On the geologic time scale these mountains are mere infants (a few tens of millions of years old). The precipitous slopes of the Rockies'

main ranges show comparatively little erosion and project themselves as naked, glacier-capped, lake-studded peaks of world renown in such parks as Banff, Jasper, Glacier, and Grand Teton. Although the Rockies are defined on their eastern flank by the Great Plains and for much of their western edge by the Rocky Mountain Trench, the characteristic Rocky Mountain ecology spills past these boundaries, particularly to the west where ranges formed by different geologic forces array themselves all the way to the Pacific Coast. Mixed in with this vast jumble of mountains is a variety of other landforms and eco-regions—foothills, plains, plateaus, deserts, sand dunes, and canyons.

In addition to geology, one of the primary interests of Rocky Mountain residents and visitors alike is wildlife. Both a seasonally harsh climate and rugged topography unsuitable for agriculture have limited human settlement, leaving much of the flora and fauna of this region intact. Regulations banning hunting in mountain parks have dispelled the fear wild animals normally have of humans, making it possible for the millions of yearly visitors to readily view furtive creatures (many are depicted in this book) in their natural habitats.

The range and distribution of most of these animals are determined primarily by climate and vegetation. The beaver, for instance, inhabits gently flowing river and stream bottoms where it can build dams and lodges. The best habitats provide swimming access to stands of birch, poplar, and aspen—trees that provide both food and building materials for this large rodent. (You will rarely find a beaver in any other habitat.) A typical Rocky Mountain slope exhibits four readily discerned vegetation patterns that provide clues not only to the presence of resident wildlife but also to the herbs and shrubs that are found there.

At the lowest elevations are prairies, sage brush steppes, or a mix of the two. These vegetation types are found at the foot of the eastern front ranges, in the valleys and wide canyon bottoms between mountains, and on some dry, south-facing slopes. During winter, numerous hoofed mammals (deer, elk, and bighorn sheep) move into these areas where snow is light and forage easier to find. They are followed by predators—mountain lion, bobcat, wolf, coyote, and grizzly. Pronghorn antelope and bison are found here year-round. In warmer seasons, the marshes, sloughs, and small lakes of lowland regions are nurseries for waterfowl, grebes, gulls, shorebirds, muskrat, beaver, otter, mink, and various reptiles and amphibians

Moving out of the flats into the foothills, lower slopes, and high valley bottoms, you begin to encounter large shrubs and small trees, which generally increase in size and density as you gain elevation. This vegetation zone, known as montane forest, harbors the greatest diversity of plants and wildlife. Douglas-fir, Ponderosa pine, lodgepole pine,

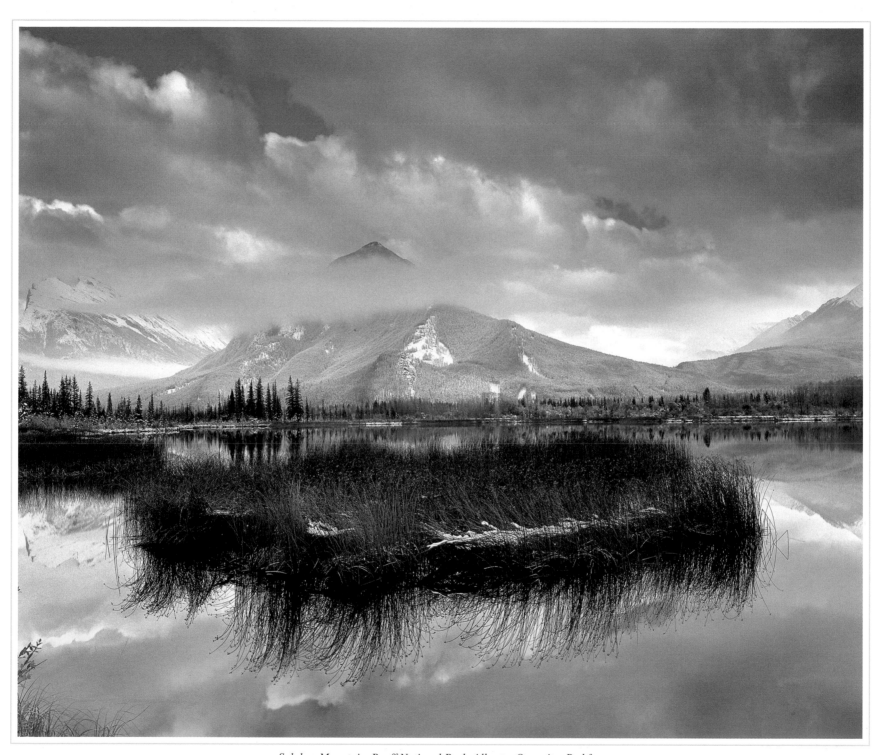

Sulphur Mountain, Banff National Park, Alberta. Opposite: Red fox.

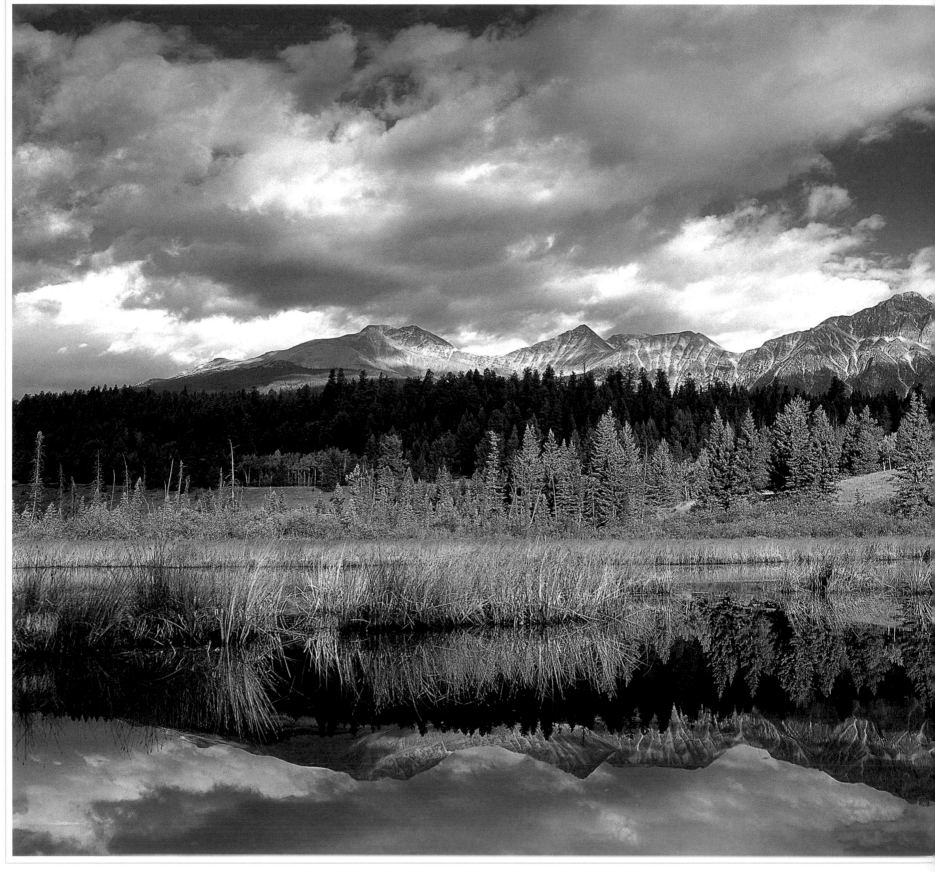

Pyramid Mountain at Cottonwood Slough, Jasper National Park, Alberta.

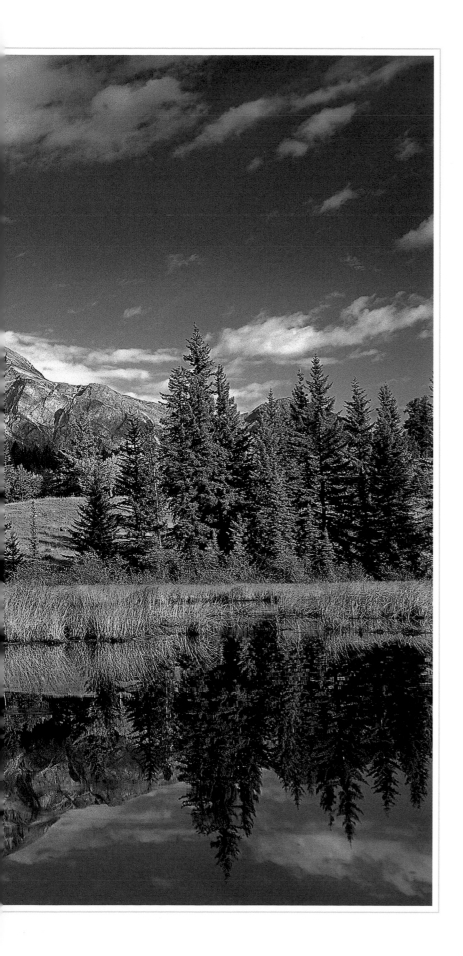

and trembling aspen are the most widespread species. At least one of them is likely to be represented in any montane forest the continent over. Ponderosa pine, with its beautiful terracotta-plated bark, adapts better than other conifers to the hot, dry climates of lower elevations bordering deserts and prairies. Colorado is the stronghold of the trembling aspen, the glory of the Rocky Mountain autumn. Pure growths of aspen cloak entire mountainsides in glinting tones of gold and bronze. Aspen woodlands are great places to find wildflowers during warmer seasons and nesting songbirds during the spring. In the south and central Rockies, white fir and blue spruce are common montane species while further north the forests are characterized by the inclusion of western larch (another autumn torchbearer and a conifer at that!), grand fir, western hemlock, and western redcedar.

Mule deer, white-tailed deer, elk, mountain caribou, moose, and their predators are common denizens of these forests. An assortment of chipmunks, tree squirrels, and ground squirrels and porcupines, varying hares, and yellow-bellied marmots are the principle smaller animals you are likely to come across.

Moving further up the mountainside, the forest becomes predominantly Engelmann spruce and subalpine fir, the latter being readily identified by its slim, spire-like, snow-shedding profile. These two principal species characterize the subalpine forest. This mix is seasoned by various other trees depending on location: balsam poplar, whitebark, limber, and bristlecone pines, and alpine larch. Subalpine forests develop a closed canopy in favorable conditions of soil, moisture, and wind. But as elevation increases, the forest inevitably thins out to open parkland, scattered patches, or ribbon stands made up of

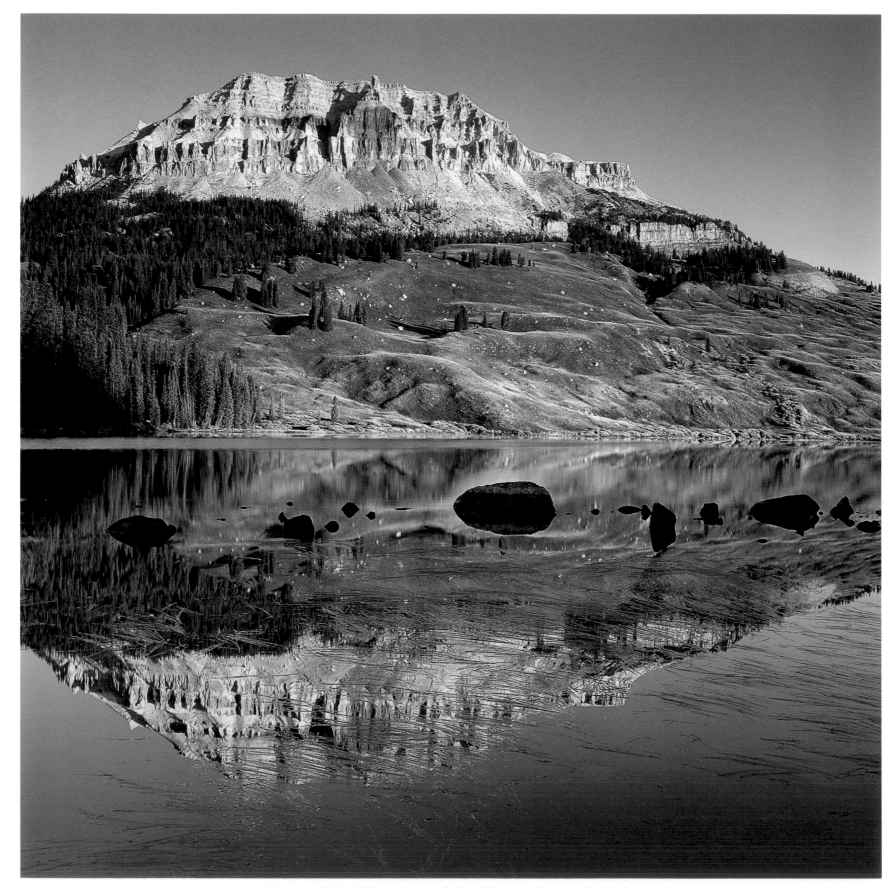

Prime grizzly bear habitat—Beartooth Butte, Wyoming. Opposite: Grizzly bear.

smaller tree specimens interspersed with lush meadows choked with great varieties and densities of wildflowers during July and August—paintbrushes, lupines, columbines, sunflowers, penstemons, cinquefoils, daisies. At timberline, the brief growing season stunts trees and they are commonly shorter than a man. During winter, gale-force winds, blowing ice crystals, and crushing snowpacks sculpt them into misshapen specimens known as *krummholz* (German for crooked trees). The wildlife of the lower subalpine forests differs little from the upper montane forests. But closer to timberline, the scattered tree clumps provide shelter for mountain goats and bighorn sheep during storms, as well as deer and elk that come up from the lower slopes and valleys to feed on alpine grasses and herbs during the summer. Bird life habitually nests in the trees and feeds in adjoining mead-

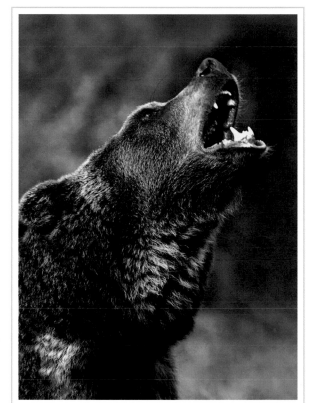

ows. Mountain bluebirds, broad-tailed, calliope, and rufous hummingbirds, robins, gray jays, and flycatchers are species that find suitable reproductive conditions near timberline. The subalpine parklands are also good habitat for pikas, marmots, ground squirrels, and pocket gophers together with their predators—coyotes, martens, weasels, bobcats, hawks, eagles, and owls.

Above timberline, the terrain is stark—rock-strewn, craggy, and seldom without wind. These habitats are generally the peaks and high, bare ridges of mountains and may be ice-covered (glaciated) the year-round. Soil occurs in pockets and is thin and poor in

nutrients. The vegetation is diminutive and hardy, consisting of tiny flowers, thin grasses and sedges, mosses, and lichens. Patterns of growth are directly affected by the manner in which snow accumulates and is removed by desiccating winds. It's too cold, windy, and dry for most wildlife at any time but the brief summer. White-tailed ptarmigan, American pipit, and rosy finch are some of the birds you might see above timberline. Spotting mammals, although they are uncommon, is generally easy due to the sparse, low-growing vegetation. Wolverines, grizzly bears, red foxes, mountain goats, pikas, golden-mantled ground squirrels, hoary marmots, bushy-tailed woodrats, and various voles, lemmings, and mice all frequent the alpine tundra during summer.

There is no better place than the Rockies to observe a wolf pack or the rutting antics of a record-size wapiti; to add a fox sparrow, mountain bluebird, or harlequin duck to your life list; to collect flowers, munch wild blueberries, tramp a mountain trail, and wet a fly line over a school of hungry trout. Hopefully these experiences will come to you. But for now, you might join me and the beaver on the banks of a still pool, the scent of pine and marsh in your nostrils, reality dissolving into dream as the setting sun illuminates the line-up of peaks.

Northern Rockies

Alberta and British Columbia

*The mountains, I become part of it . . . The herbs, the fir
tree, I become part of it. The morning mists, the clouds, the
gathering waters, I become part of it.*

—Navajo Chant

Snow is falling in little puffy flakes, oscillating earthward through the dry, cold air of autumn. It piles up in the thick ruff on the elk's shoulders. The bull lifts his head. Eyes reddened, muzzle dripping strings of saliva, he opens his mouth and expels a cloud of vapor. The still atmosphere is fractured by a roar and then a clear, drawn-out, bugle-noted challenge that ends with a few quick, coughing grunts; all in all not unlike the screech of rusty train wheels moving along a track. Bad-tempered, aggressive, with antlers spanning 5 feet (1.5 m), and weighing more than 1000 lb. (450 kg), the bull elk is the monarch of the Canadian Rockies.

Although elk are usually the scene-stealers in the Rockies of Alberta and British Columbia, in general this region offers the most dramatic combination of wildlife viewing and breathtaking mountain vistas in North America. Unlike the ranges south of the border, the Canadian Rockies are organized into parallel north-south running ridges often of easily recognizable structure. Typically found in the front ranges are over-thrust mountains, formations with stepped cliffs to the northeast and tilted, table-flat slopes running off to the south-west. Formed by over-thrusting layers of the earth's crust, Mount

Rundle and Sunwapta Peak are typical examples. Dogtooth mountains were formed when the earth's layers were tilted to the vertical and then eroded leaving toothy spires. Sawtooth formations (Colin Range) are similar to dogtooth mountains except the earth's layers did not reach the vertical, and where angled into prevailing winds and precipitation, the softer rock has weathered away leaving angled ridges that from a distance look like the teeth of a saw. Castellated mountains (Castle Mountain and Mount Crandell) are horizontal layers composed of soft rock that erodes to become ledges, and harder material that remains to form cliffs, the result being the trademark layer-cake peaks of the Canadian Rockies. Last are the horn forma-tions (Mount Chephren, Mount Assiniboine, Mount Kidd) created when several circular glaciers ground off adjacent, opposing surfaces to form pyramidal or horn-like peaks. Of course you will come across many mountains that don't seem to fit these categories due to the great range of geologic processes at work on the land. Such alpine phenom-ena are in evidence both inside and outside national and provincial parks but three areas, all in Alberta, are particularly spectacular—

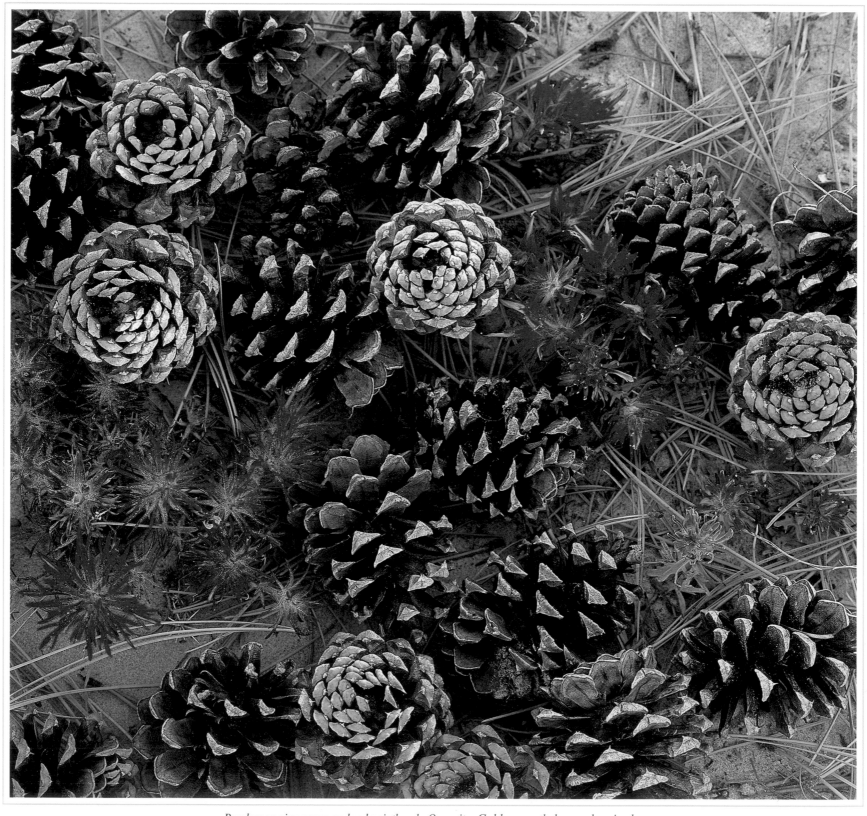

Ponderosa pine cones and red paintbrush. Opposite: Golden-mantled ground squirrel.

Banff Nationa Park, Jasper National Park, and Kananaskis Country.

Each year more than nine million people pass through Banff National Park, North America's second oldest national park (after Yellowstone). It arguably shares with Yellowstone the honor of being the most famous park on earth—for good reason. The list of natural attractions is unmatched by any other Rocky Mountain location—the soaring profile of Mount Rundle seen from Vermilion Lakes, the power of Bow Falls, the emerald waters of Lake Louise with the Victoria Glacier backdrop, Moraine Lake and the brooding Wenkchemna Peaks, and the Icefields Parkway, a road lined with waterfalls, pristine lakes, and monumental glaciers for much of its 120 mi. (200 km) length. These examples only hint at the abundance of world-class alpine scenery. The valleys are frequented with elk, mule deer, coyote, and black bear; the higher slopes are home to mountain goat, bighorn sheep, and grizzly. The skies are traced with the flights of raven, osprey, and bald eagle; the marshes are inhabited by waterfowl, moose, otter, mink, beaver, and muskrat.

Jasper National Park is Banff's twin, forming its northern border and possessing a nearly equal frequency and drama of high peaks and sprawling glaciers, especially along the northern half of the Icefields Parkway which lies within its boundaries. A principal attraction is the Maligne Lake Road, one of the best routes in the Rockies for viewing big game species during summer and winter. Along its 27 mi. (44 km) length lies Maligne canyon, the deepest, steepest limestone canyon in the Rockies, and at its end is Maligne Lake, the largest natural lake in the Canadian Rockies surrounded by postcard arrangements of glaciated peaks and punctuated in its center by Spirit Island.

Perhaps the best place to observe rutting bull elk at close range is Jasper National Park during late September and October when a dozen trophy-sized specimens compete for females on established territories in the vicinity of Jasper townsite.

There are many other areas of the Canadian Rockies of equal glory (although of lesser extent) than Banff and Jasper. Kananaskis Country is the most prominent example. It lies on the eastern flank of the Rockies and offers a milder, sunnier, less crowded alpine experience with good opportunities to view moose and bighorn sheep right beside the road. Another pocket jewel is set in Yoho National Park, next door to Banff: storybook Lake O'Hara, its azure waters surrounded by snow-capped peaks, draws wilderness lovers from all over the world.

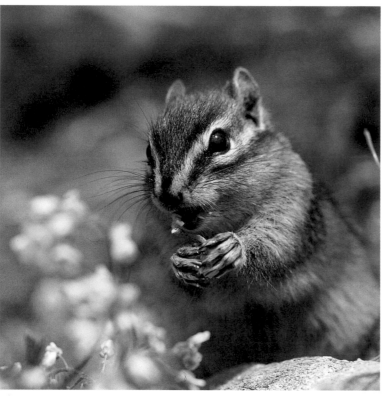

Yellow pine chipmunk.

referring areas of open coniferous forest, chaparral, pine parkland, or burned-over sites with brush and rocks, the yellow pine chipmunk appears above ground shortly after sunrise. It spends the daylight hours in search of a variety of foods, zipping about the home territory to chase down a beetle, gather seeds, or feast on berries. This booty is stuffed into the chipmunk's elastic cheek pouches and carried back to the burrow for storage. During winter, the chipmunk is seldom seen above ground, passing the colder months in sleep, stirring occasionally to grab a quick snack from one of its subterranean caches.

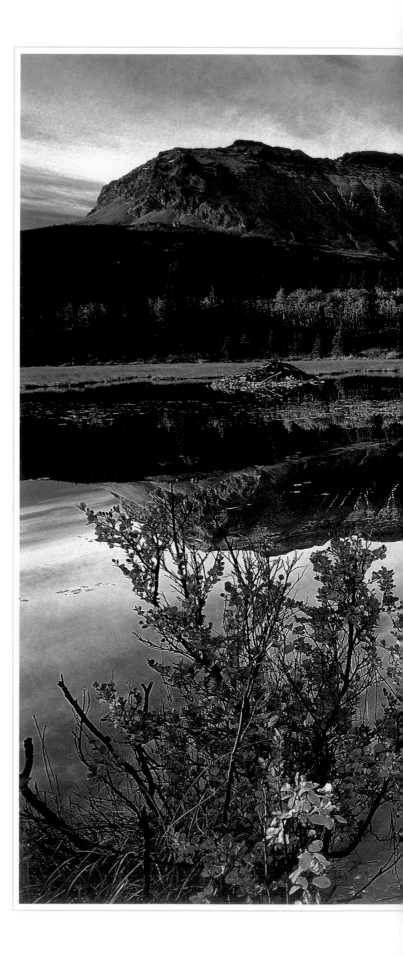

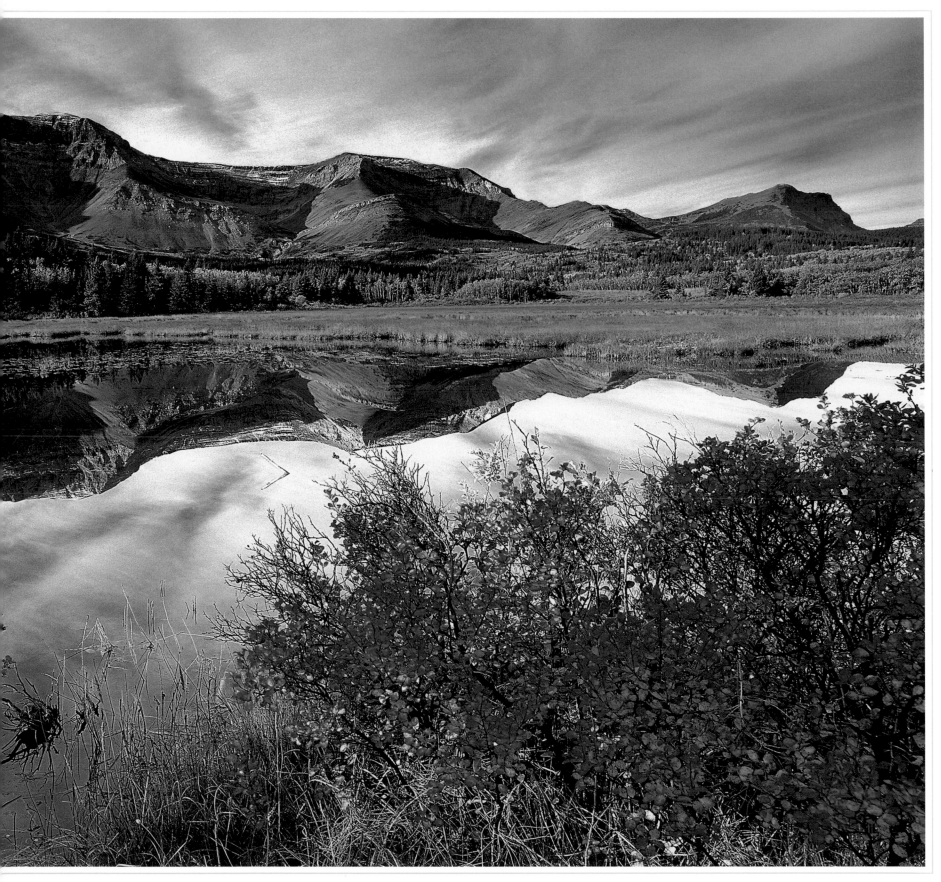

Sofa Mountain, Waterton Lakes National Park, Alberta.

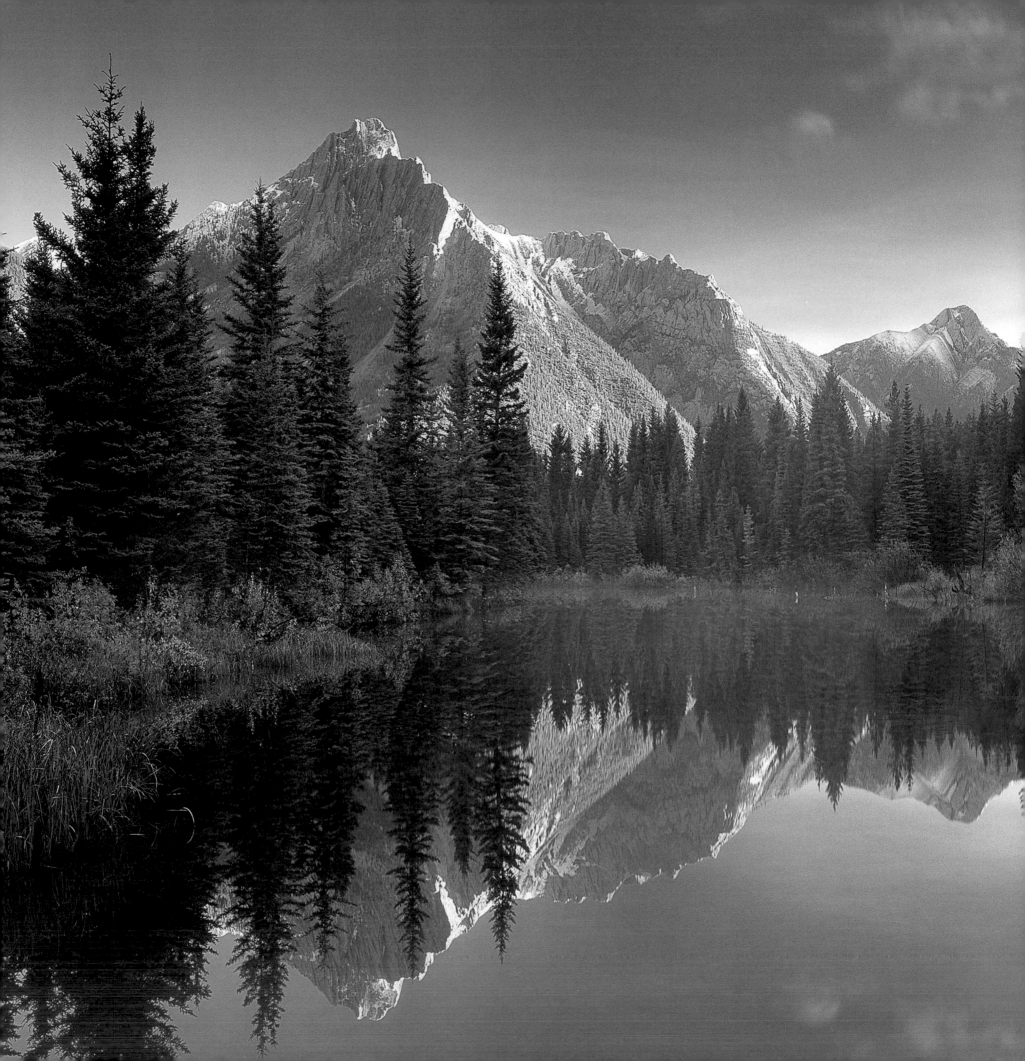

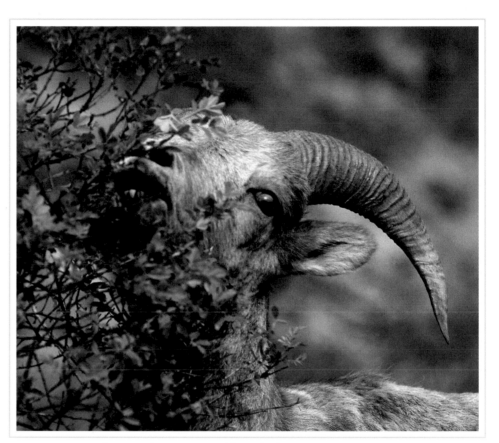

Bighorn ram browsing on wild rose bush. Opposite: Mount Lorette,
Kananaskis Country, Alberta.

Bighorn sheep are primarily grazers,
sustaining themselves on a diet of grasses and sedges. They crop vegetation while
on the move and leave little impact on their habitat, unlike domesticated sheep. A
heavy use of browse plants, such as wild rose, pasture sage, bearberry, Douglas-fir,
and juniper, indicate a scarcity of other foods. They are diurnal animals, feeding
for an hour or two at dawn, at midday, and again in the evening.

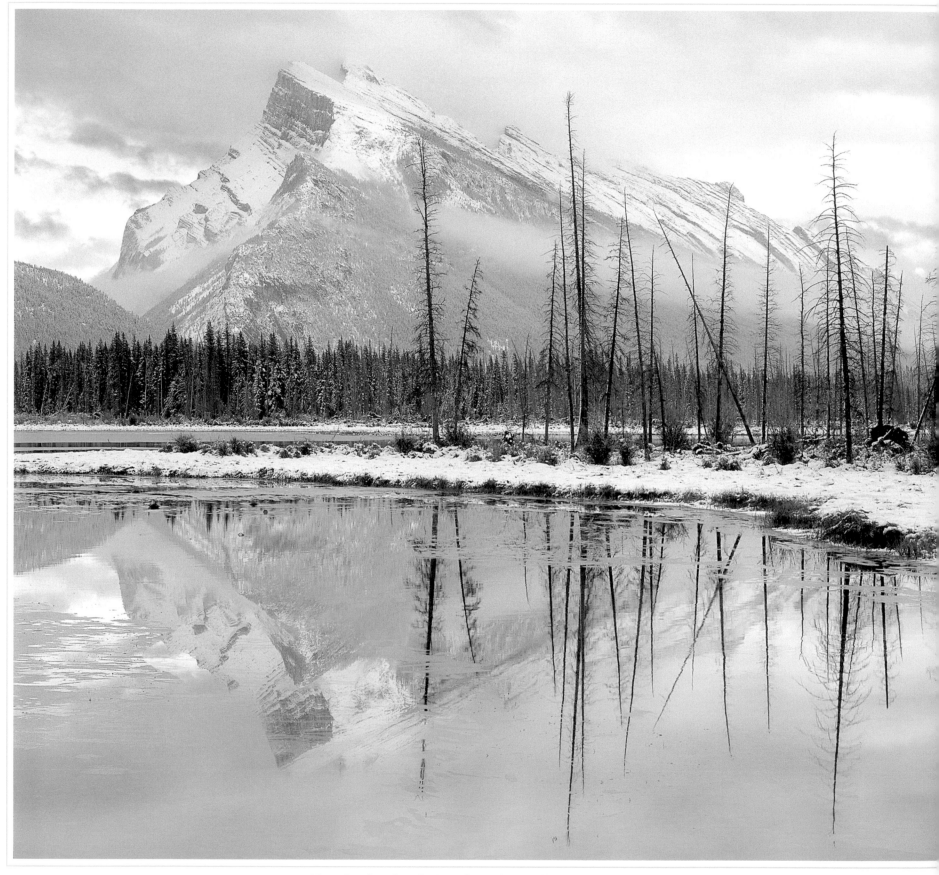

Mount Rundle reflected in Vermilion Lakes, Banff National Park, Alberta.

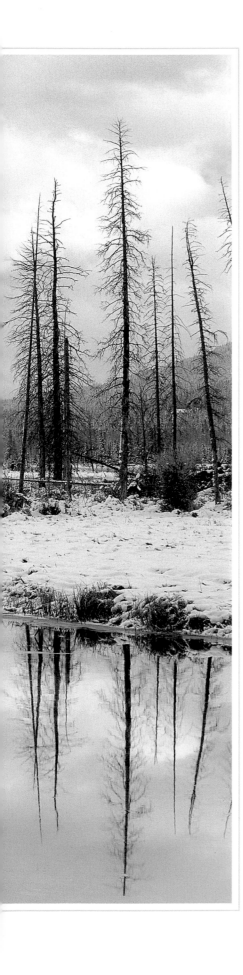

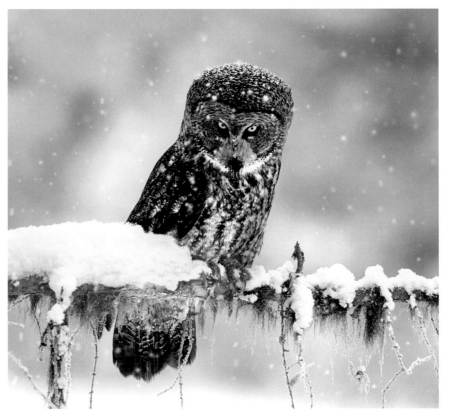

Great gray owl on hunting perch.

The largest owl in North America,
the great gray owl is about 30 in. (76 cm) long with a wingspan of
5 ft. (1.5 m). It is able to locate its prey—mice, voles, and shrews—by
sound alone. The large facial disks surrounding the eyes funnel sounds
to ear openings on the side of the head. This owl is seen most often
perched on a branch over an open meadow, listening and watching
intently for prey in the grasses below.

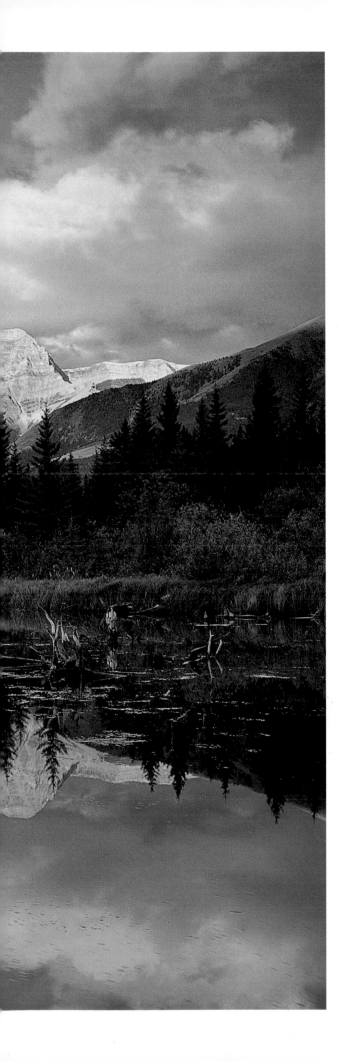

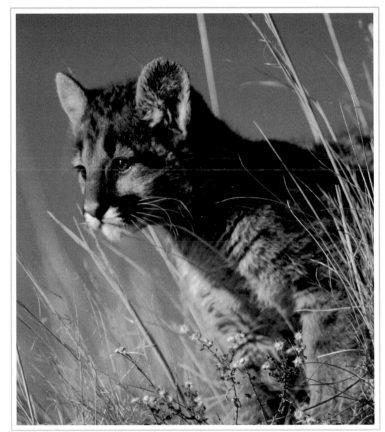

Mountain lion kitten.

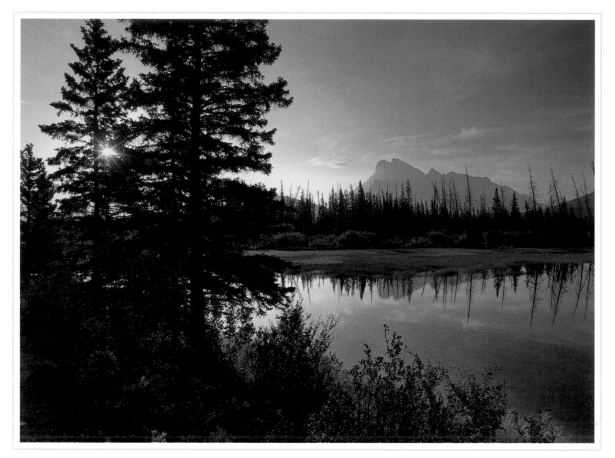

Mount Rundle and Vermilion Lakes at sunrise, Banff National Park, Alberta. Opposite: Immature bald eagle.

The wetlands at Vermilion Lakes are one
of the best places in Banff National Park for birdwatching. Here you are likely
to see ospreys, bald eagles, and kingfishers as well as various species of shore-
birds (snipe and lesser yellowlegs) and waterfowl (Canada geese, common
mergansers, mallards). Hotsprings at the western end keep portions of the lakes
open in winter, attracting waterfowl that would normally migrate
further south. Beaver, muskrat, and moose are also common inhabitants.

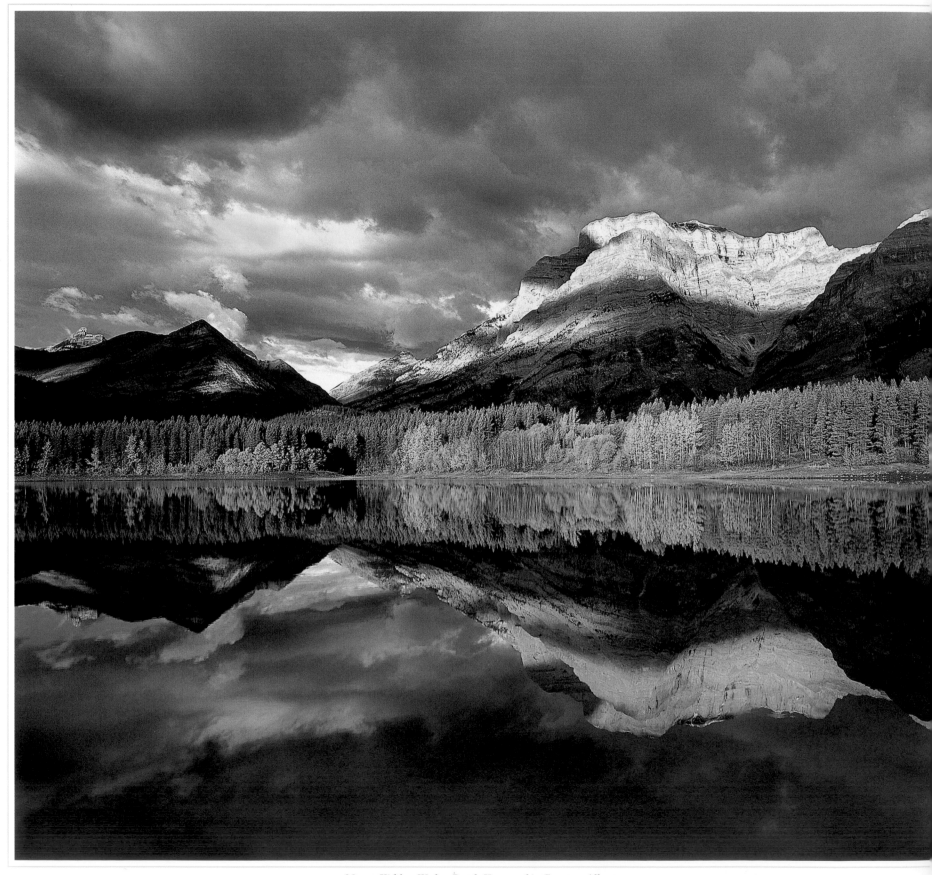

Mount Kidd at Wedge Pond, Kananaskis Country, Alberta.

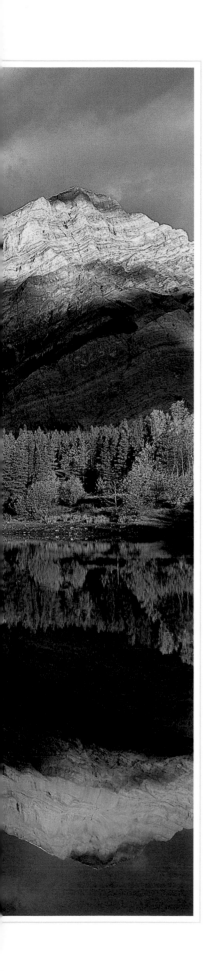

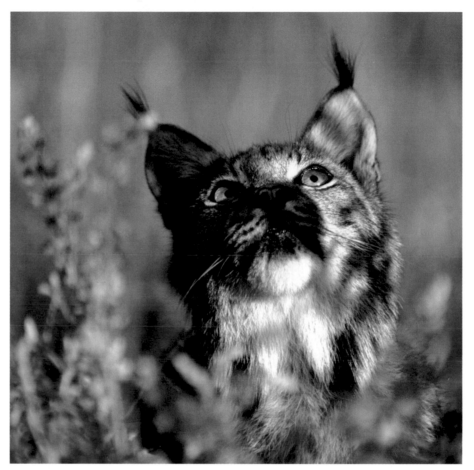

Lynx.

Although the lynx preys mainly on varying hares, it also kills young deer, moose, and a variety of birds. It is well adapted to mountain habitats and roams easily over deep snows on wide, padded paws as large as saucers. These graceful, lanky cats can grow to more than 3 ft. (0.9 m) and weigh over 35 lb. (15.9 kg). A lynx requires a home range of about 60 sq. mi. (150 sq km) making large contiguous areas of wilderness necessary to sustain viable populations.

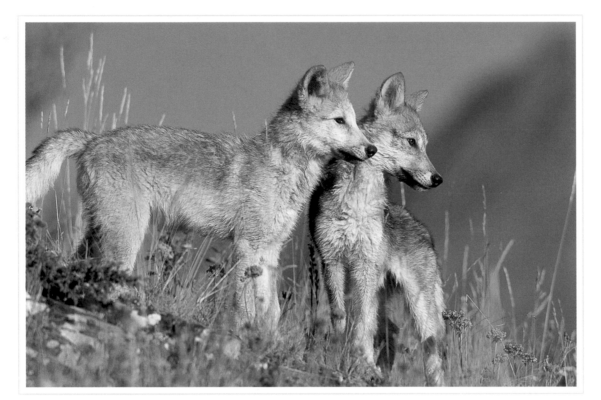

Wolf puppies. Opposite: Victoria Glacier at Lake Louise, Banff National Park, Alberta.

Visited by more than a million people each year, Lake Louise is one of the Rockies' premier scenic attractions. Fed by glacial meltwater, it is a calm emerald pool 1.4 mi. (2.4 km) long, 1640 ft. (500 m) wide, and 295 ft. (90 m) deep. Nearly surrounded by ice-capped peaks, it is dominated at its southwestern shore by Mount Victoria (11,364 ft./3,464 m) and its great glacier perched high above the cold waters. The emerald color of alpine lakes is caused by fine particles of glacial sediment suspended in the water that reflect primarily blue and green wavelengths of light.

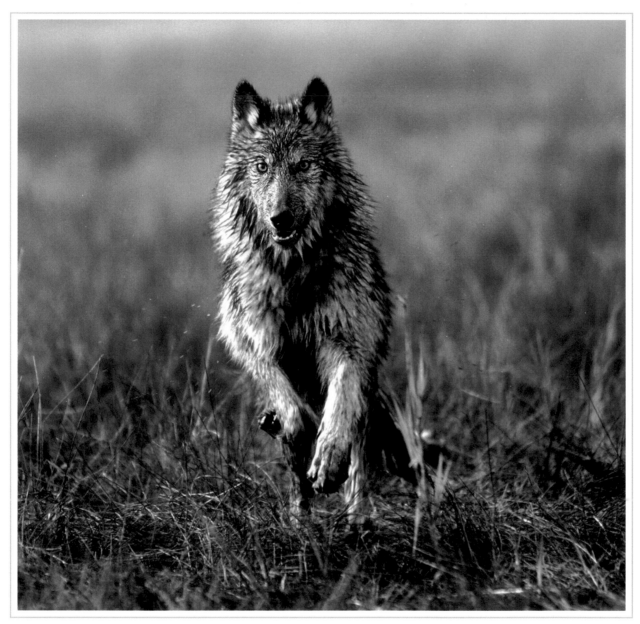

Running wolf. Opposite: Mount Saint George and Summit Lake, Stone Mountain Provincial Park, British Columbia.

The wolf is commonly found throughout the
Canadian Rockies and in scattered packs in Idaho, Montana, and Wyoming where it has been
reintroduced successfully. Wolves run with a lumbering gait with tails streaming behind,
reaching speeds of 30 mph (50 kph) over short distances, not particularly fast when compared to
their principal prey—elk and deer. Wolves overcome this handicap by killing individuals that
are young, old, or sick. They also hunt cooperatively, some of the pack driving game to others
that lie in ambush, or they drive the quarry into terrain more favorable to themselves, such as
crusted snow, swamp, or ice.

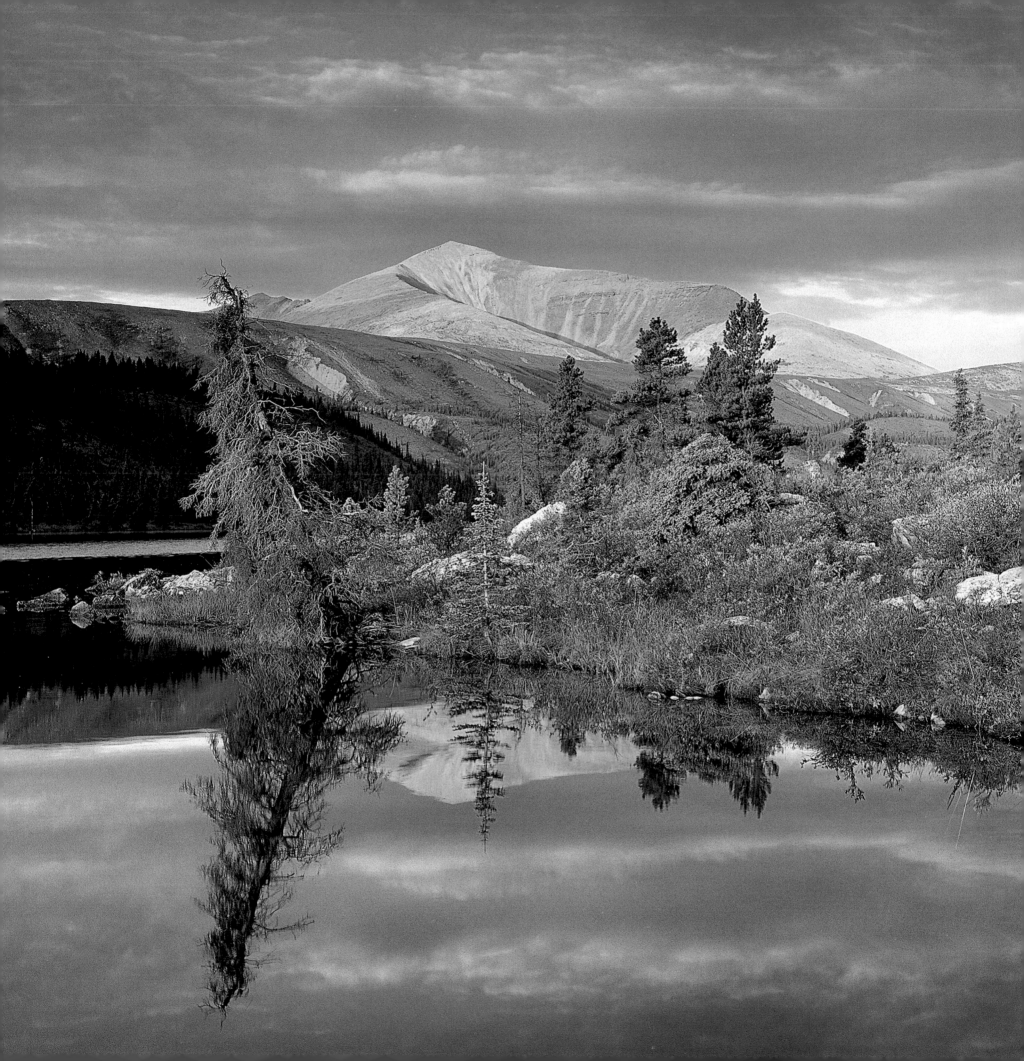

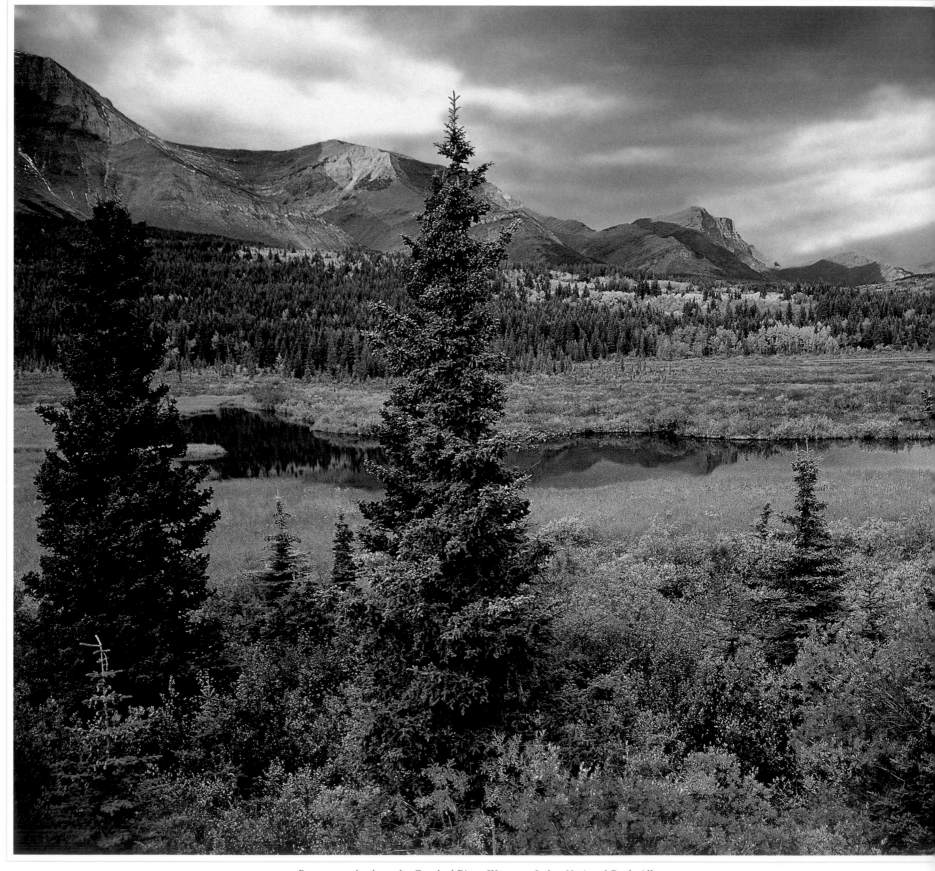

Beaver ponds along the Crooked River, Waterton Lakes National Park, Alberta.

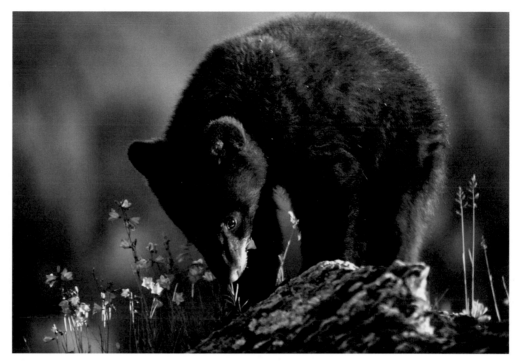

Black bear cub.

Black bears are common throughout the
Rocky Mountain chain. They kill the young of deer, elk, and moose as well as
smaller animals such as ground squirrels, beavers, and marmots. But most of their
nutrition is derived from plant sources—the roots and tubers of wildflowers and
grasses, as well as berries and nuts. Although lacking the ferocious reputation of
their larger cousin, the grizzly bear, black bears are nevertheless dangerous and
should be avoided whenever possible. Numerous fatal attacks have occurred in
recent years, and unlike the grizzly, which cannot climb trees, there is no refuge
from a hungry and detemined black bear.

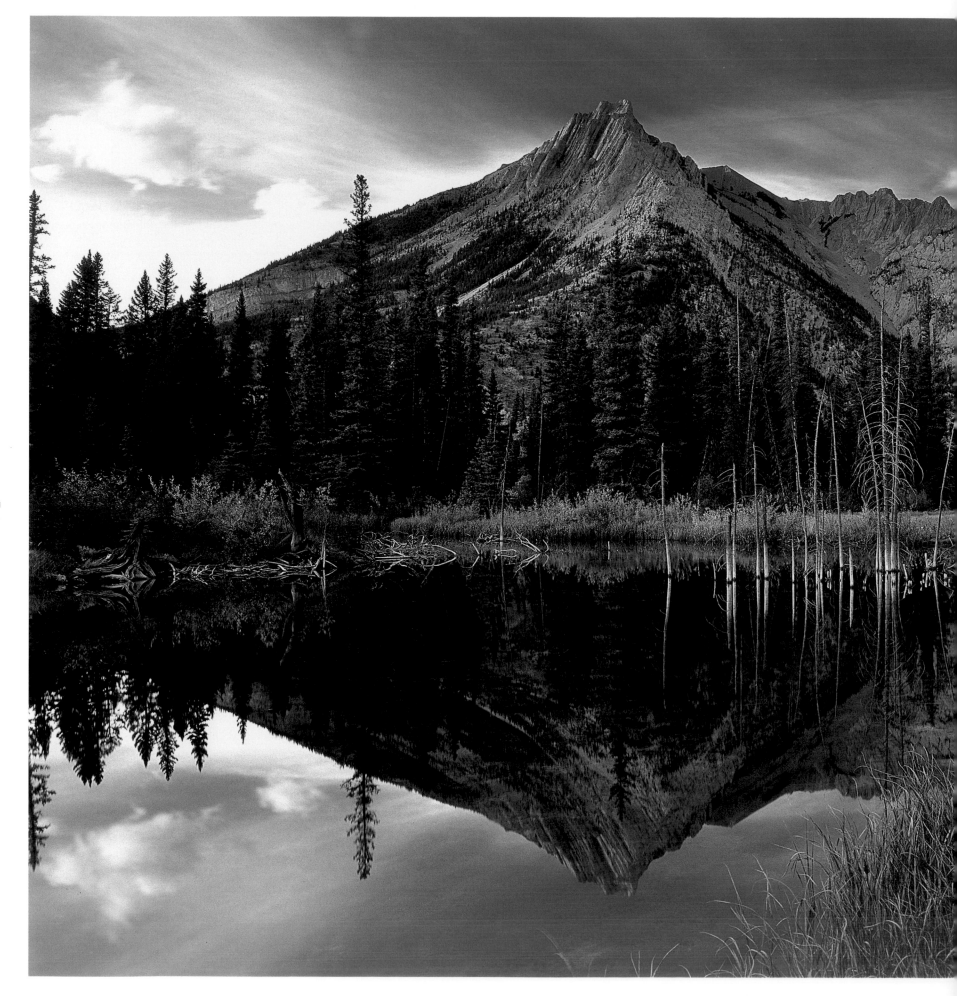

The largest members of the squirrel family, adult hoary marmots weigh up to 30 lb. (13.6 kg). They inhabit alpine meadows, talus slopes, and cliffs at and above timberline. They spend about eight months of each year in deep hibernation, emerging in late April to begin a summer of bingeing on wildflowers, grasses, and berries of the alpine zone.

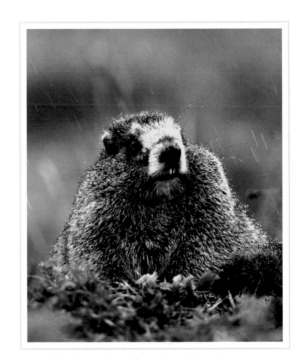

Hoary marmot. Opposite: Mount Lorette, Kananaskis Country, Alberta.

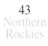

Mount Chephren and Lower Waterfowl Lake, Banff National Park, Alberta.

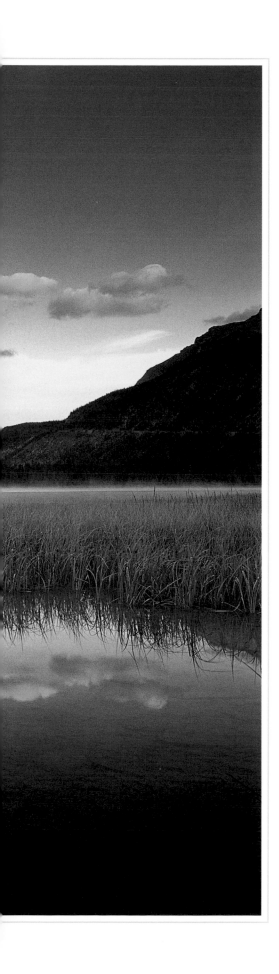

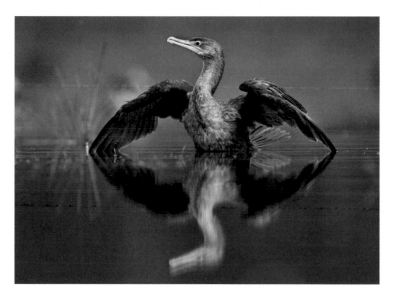

Double-crested cormorant.

The double-crested cormorant is not
the most lovable of birds. It has a sinister, hawk-like visage, dark greasy
plumage, and a weak croaking call; it feeds its young regurgitated fish and
its breeding colonies are plastered with its own haphazard droppings.
Aesthetic reservations aside, the cormorant is to be admired for its adaptive
abilities. Found throughout much of the Rocky Mountain region, it is often
seen perched on a log or sandbar drying its wings in the sun.

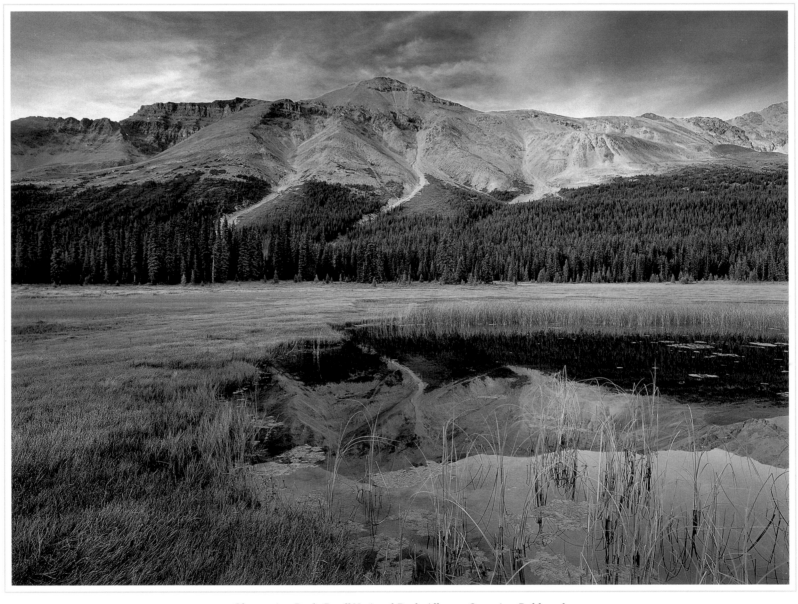

Observation Peak, Banff National Park, Alberta. Opposite: Bald eagle.

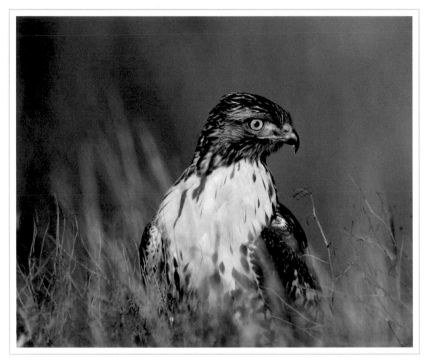

*Red-tailed hawk. Opposite: Syncline Ridge and Roche Miette
at Jasper Lake, Jasper National Park, Alberta.*

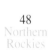

The red-tailed hawk is the most
common soaring hawk of the Rocky Mountain region. Identifi-
cation of this raven-sized raptor when perched may be difficult
due to its variable plumage, but once it takes to the air, its rusty-
red tail and distinctive, plaintive call—a harsh, descending
keeerrrr—is unmistakable. This hawk hunts roadside ditches,
open meadows, and lake shores for small rodents, large insects,
and birds. You will often see it sitting immobile on an
overhanging branch, peering intently into the grasses below.

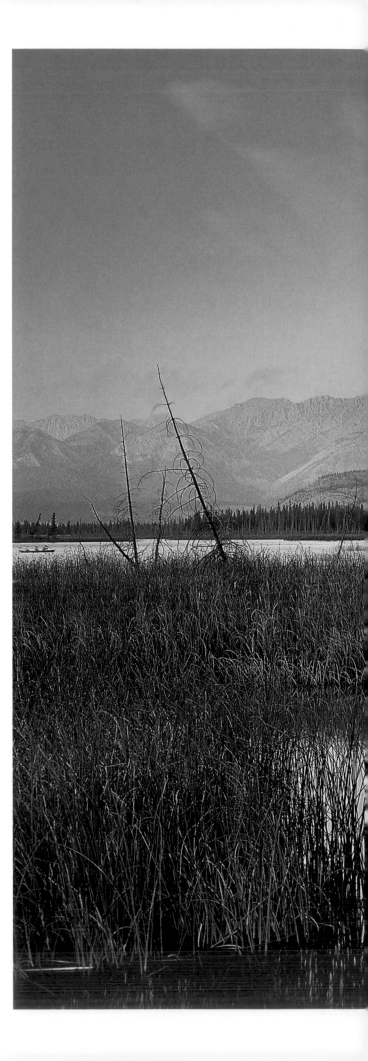

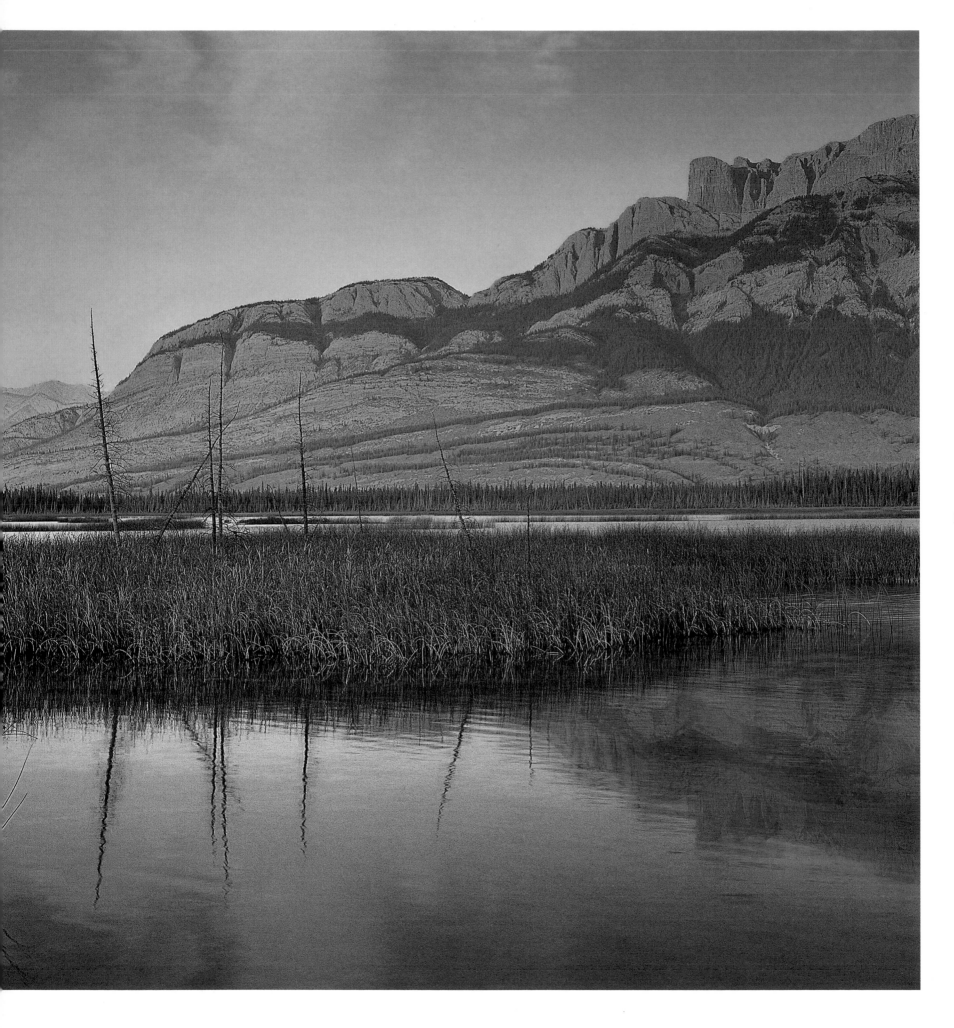

The mountain goat, a member of the antelope family, is the most skilled rock climber of all North American mammals, inhabiting some of the roughest terrain in the Rocky Mountain ecosystem. Unlike other hoofed mammals which migrate to lower elevations in winter, mountain goats generally occupy the same ranges year-round. Equipped with short, muscular legs, non-skid soles, and flexible toes, mountain goats clamber over near-vertical rock faces where few other animals venture. Such precipitous terrain is safe refuge from most predators with the exception of the mountain lion. These big cats stalk mountain goats in the manner of the domestic cat, springing from hiding onto the prey's back or shoulder, knocking it to the ground where it is held immobile by strong claws and dispatched with prominent canine teeth.

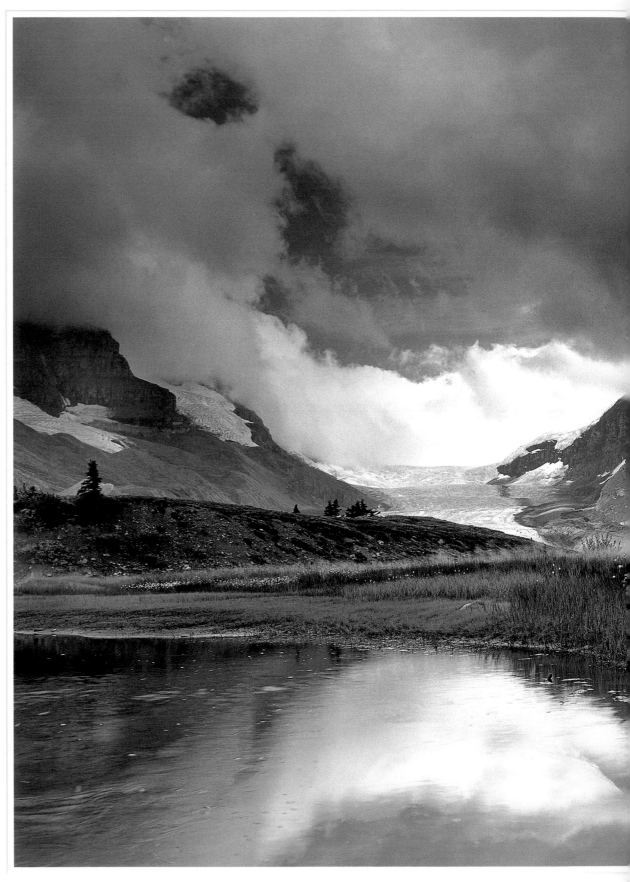

Athabasca Glacier, Columbia Icefields, Jasper National Park, Alberta.

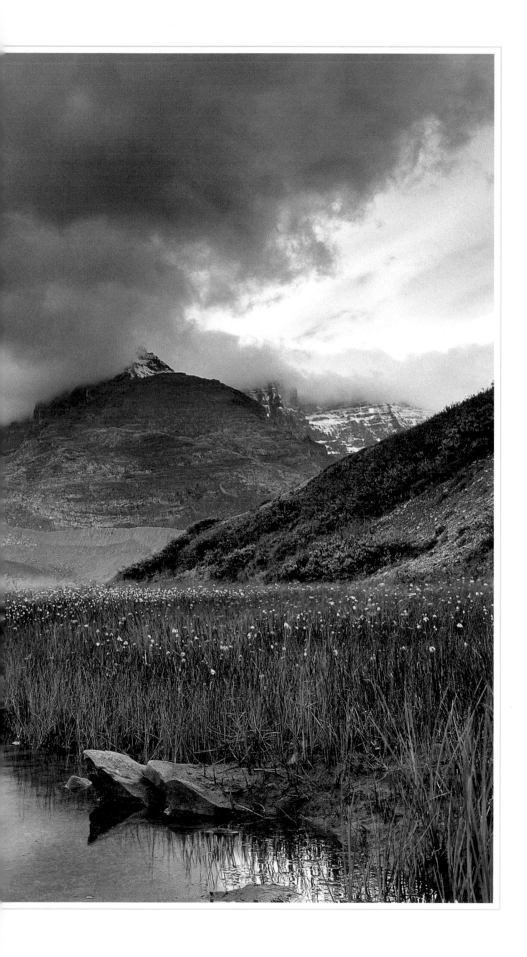

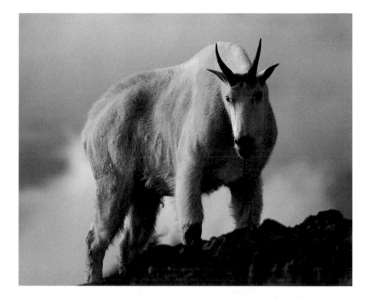

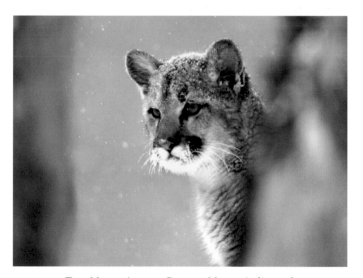

Top: Mountain goat. Bottom: Mountain lion cub.

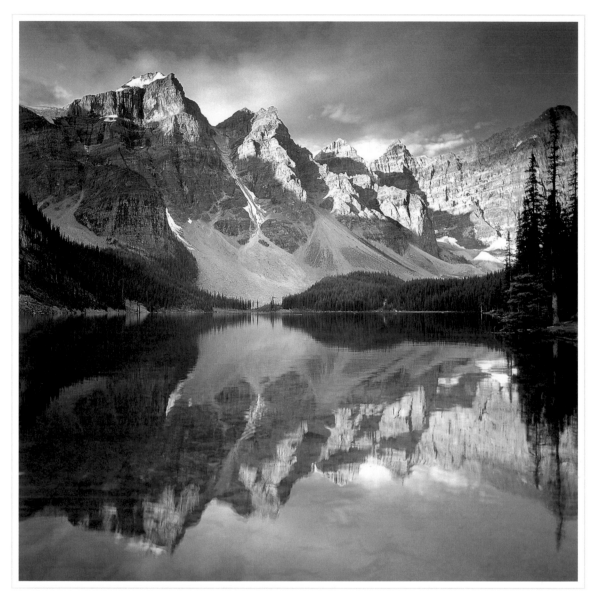

Wenkchemna Peaks reflected in Moraine Lake, Banff National Park, Alberta. Opposite: Lesser scaup drake.

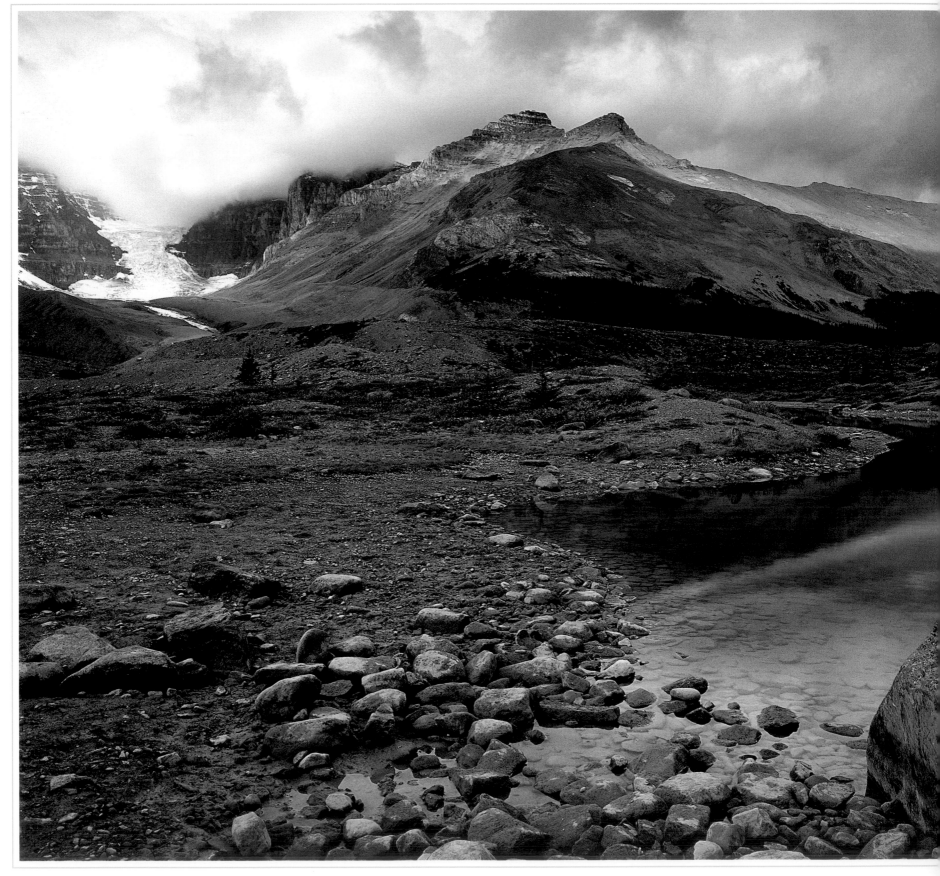

Dome Glacier, Jasper National Park, Alberta

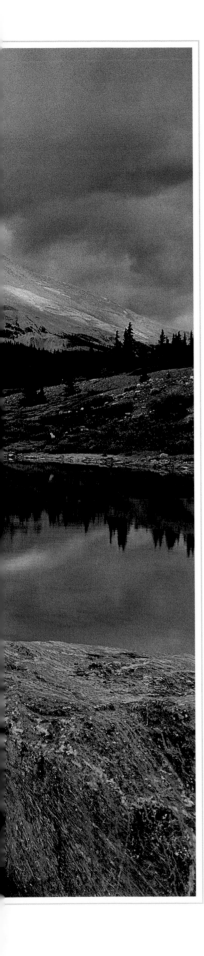

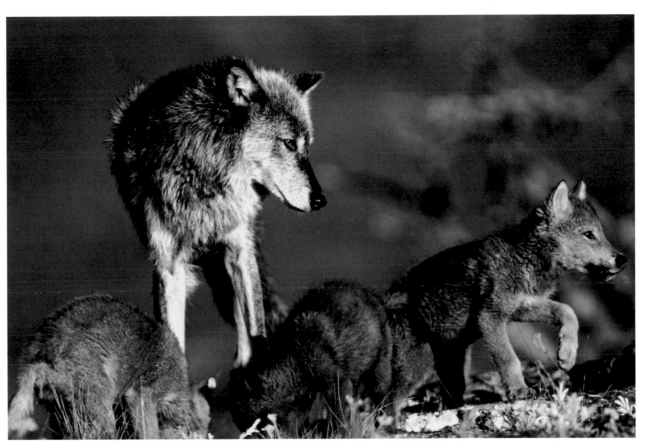

Wolf mother and puppies.

Wolves associate in large family groups led by an experienced male and female. The male brings food to the nursing mother and later to the pups. Should the mother die, the father will take over care of the young, and if they are not yet weaned, another pack female (likely an aunt) may adopt them. Unmated aunts and uncles care for the puppies while the rest of the pack is hunting. Members of the pack bond by romping, nuzzling, and tail-wagging.

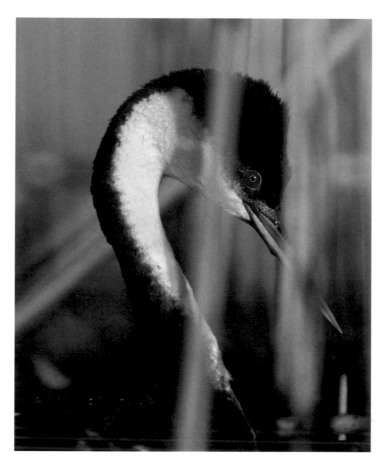

Western grebe.

The western grebe breeds at
lower elevations on small lakes and large ponds throughout the Rocky
Mountain region, building its floating nest among reeds in shallow
water. It is an aquatic specialist and, like all grebes, has powerful legs
mounted well to the rear, like the tail fin of a fish, and long, lobed toes
for grabbing the water. It has short, stubby wings and takes to the air
like an overloaded seaplane, running along the surface for a
considerable distance to build up speed for lift-off.

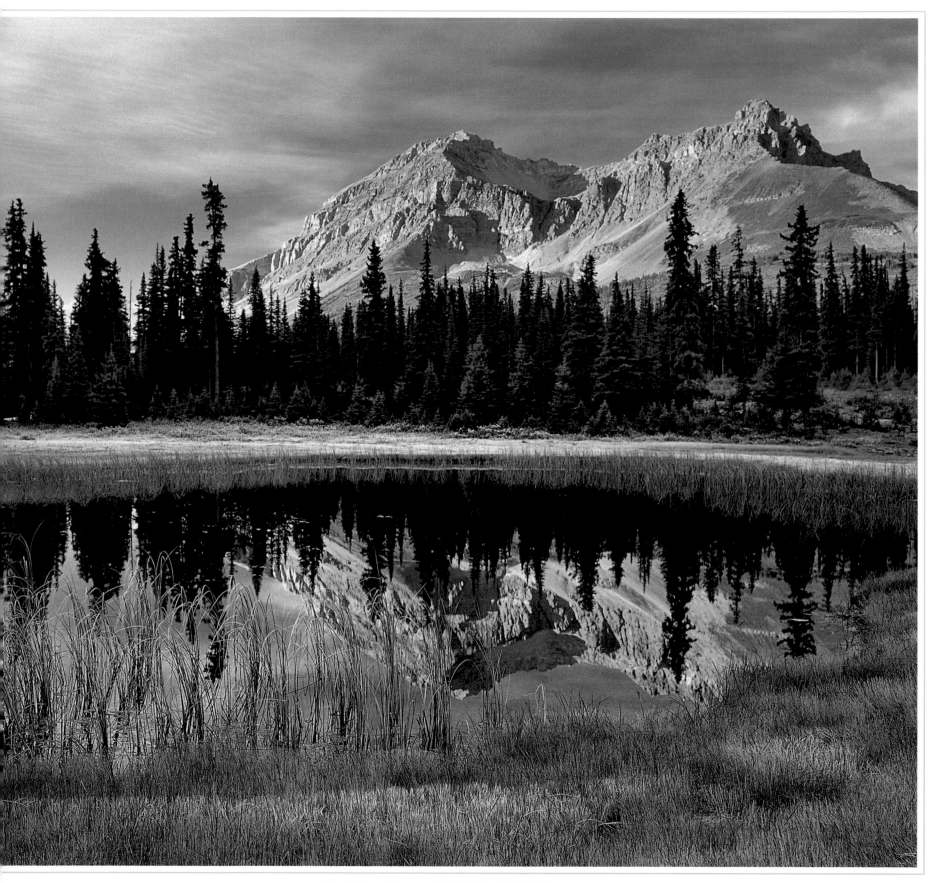

Mount Jimmy Simpson, Banff National Park, Alberta.

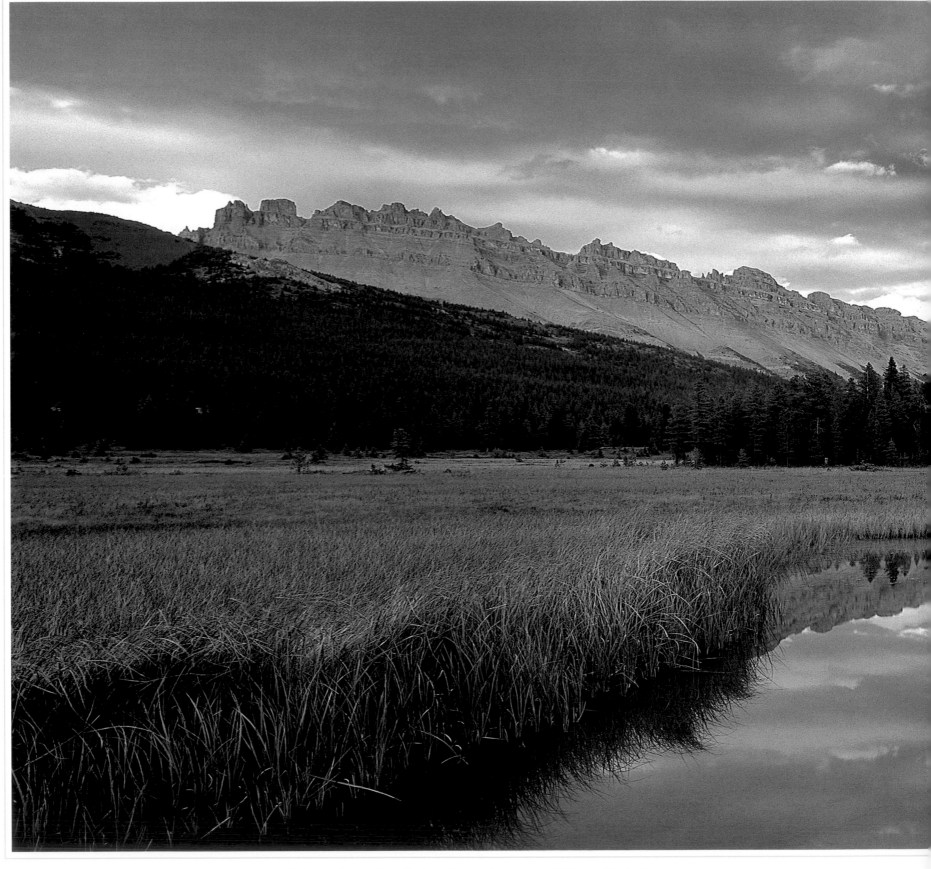

Dolomite Peak reflected in Bow River backwaters, Banff National Park, Alberta.

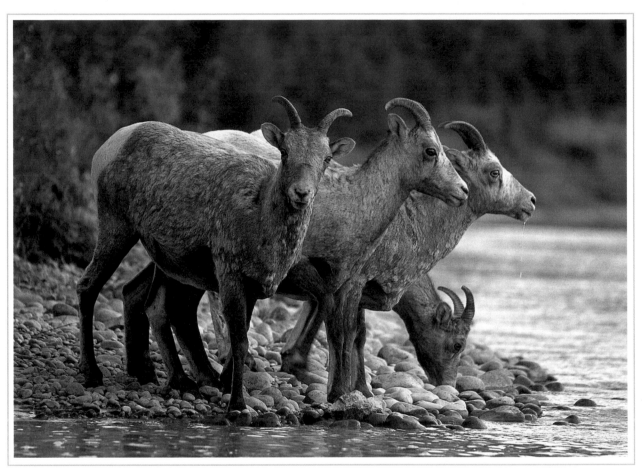

Bighorn ewes drinking. Opposite: Mount Robson, Mount Robson Provincial Park, British Columbia—the highest peak in the Canadian Rockies at 12,972 ft. (3,954 m).

Bighorn sheep live in small, sexually segregated groups. Led by older females, these maternal bands consist of ewes, lambs, and immature rams. They feed and migrate separately from the older males, which gather in their own small herds. During the summer, all sheep wander in search of rich grasslands and mineral licks. While feeding in open terrain, their herding behavior gives protection from predators, mainly mountain lions and wolves.

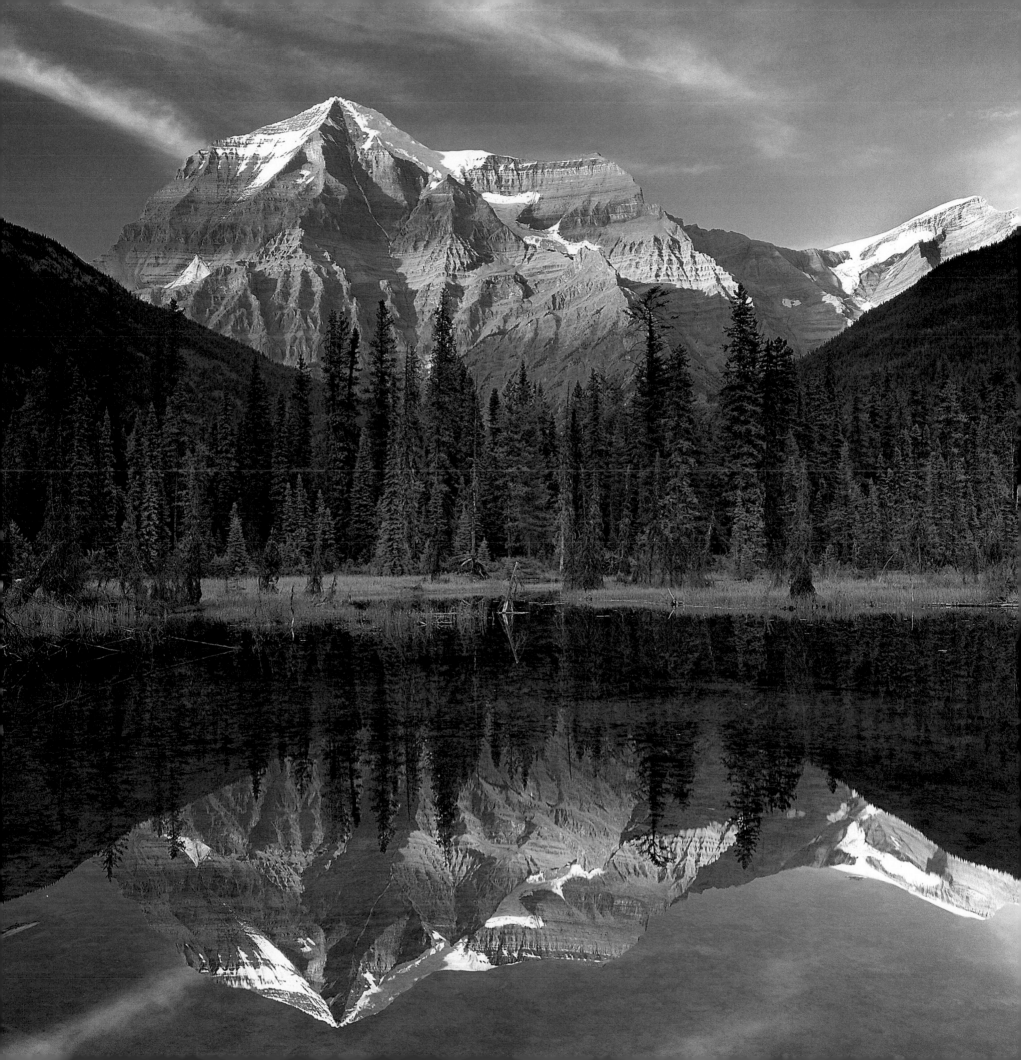

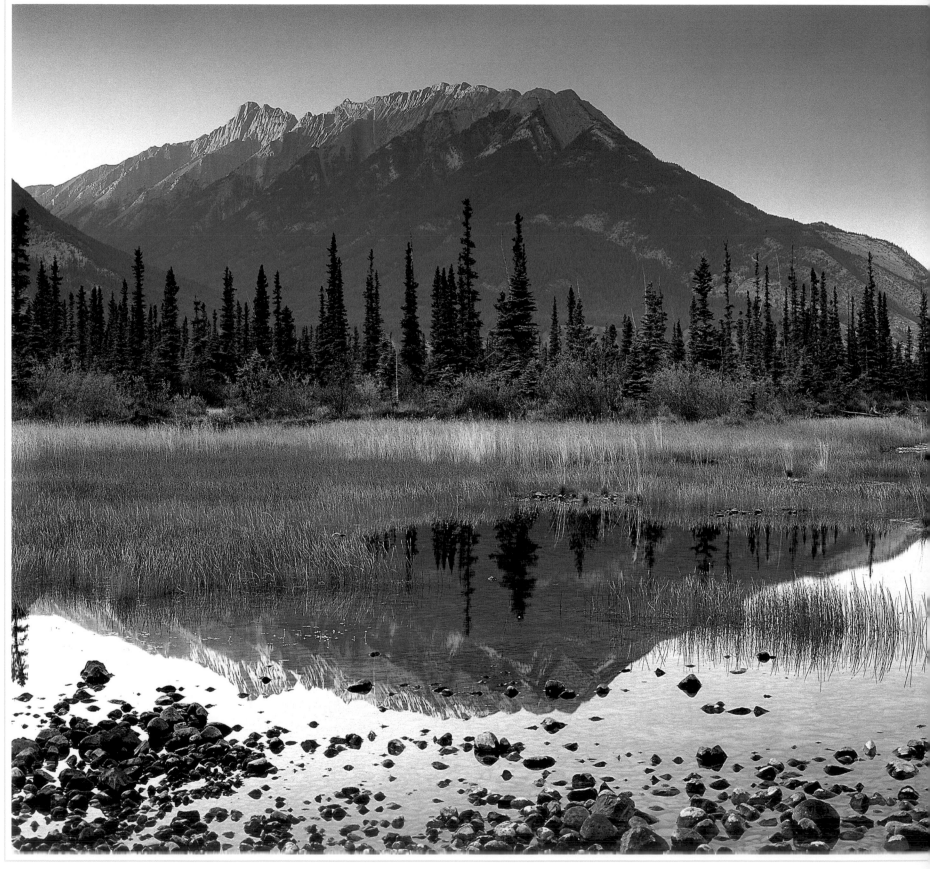

Selwyn Range, Mount Robson Provincial Park, British Columbia.

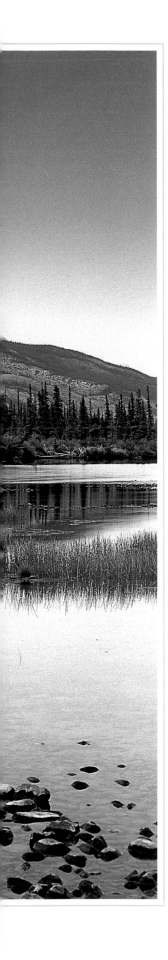

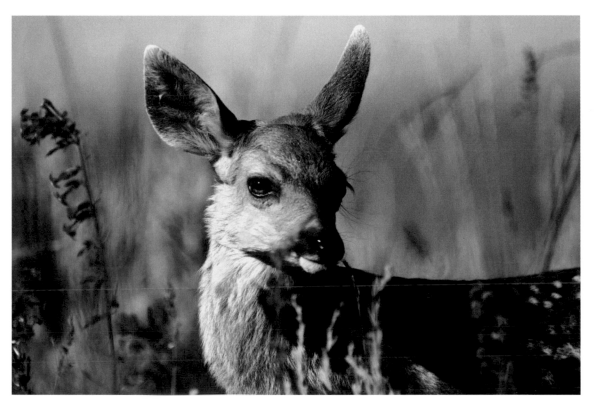

Mule deer fawn among scarlet trumpets.

The mule deer is named for its large, mule-like ears which, along with its nose, help it detect predators. Fawns, odorless and weighing about 8 lb. (3.6 kg) at birth, are common prey for wolves, coyotes, mountain lions, and grizzlies. Until they develop the strength and agility to outrun predators, fawns are hidden in secluded glades for the first month of life while their mothers browse nearby. They lie motionless with legs tucked under and necks extended. Mule deer migrate seasonally, moving up to higher elevations during summer and retreating to warmer valleys during winter.

Central Rockies

Idaho, Montana, and Wyoming

You ask why I perch on a jade green mountain? I laugh but say nothing, my heart free like a peach blossom in the flowing stream going by in the depths in another world not among men.

—Li Po

Front hooves held aloft, eyes wide and blank as stones, the two rams are suspended in imminent collision. As if controlled by a single brain, the rear hooves thrust simultaneously against the gravel of the thin alpine soil, driving the sets of massive, rippled horns into one another—*clonk*. The sound is tight, an understatement; it lies flat against the mountainside and dies abruptly. There is no emotion, no giving of ground, no heaving of breath. The animals meet like a simple, single clap of the hands. After millions of years of rehearsal, this alpine dance is precise, and for the moment the combat is only ritual.

Although bighorn sheep roam throughout the Rocky Mountain region, it is in the central Rockies where they and other wildlife species are found in greatest abundance. Here the alpine landscapes are no less magnificent than in Canada, but the general impression is less powerful, for the ranges are scattered and interspersed with broad valleys of rich grasses and year-round water. Such topography is ideal for wildlife that can pass the summer feasting on the temporary lushness of the high country,

retreating to the relative warmth of the valleys when winter buries the alpine in snow and ice. The most dramatic samples of mountain terrain are preserved in government parks—Glacier, Yellowstone, and Grand Teton National Parks being the most important. Resting against the Alberta border in northwestern Montana, Glacier National Park is a pristine wilderness of over a million acres. Adorned with more than 200 lakes, 60 glaciers, and nearly 1,000 mi. (1,600 km) of rivers, the park is bisected by one slim line of pavement (Going-to-the-Sun Road), stretching for 50 mi. (80 km) from Lake MacDonald on the western boundary through Logan Pass at 6,664 ft. (2,031 m) to join Lake Saint Mary in the eastern reaches of the park. This road gives the motorist a glimpse of Glacier's natural splendors—great green slopes clothed with wildflower meadows, quilted by patches of pine, spruce and aspen, and smothered in places with thick mantles of giant conifers like those in the Pacific Northwest. These vegetative fabrics wrap themselves about the feet of raw rock inclines and towering glacier-dappled massifs.

The restrained ballet of the bighorns is counterpoint to the heavy,

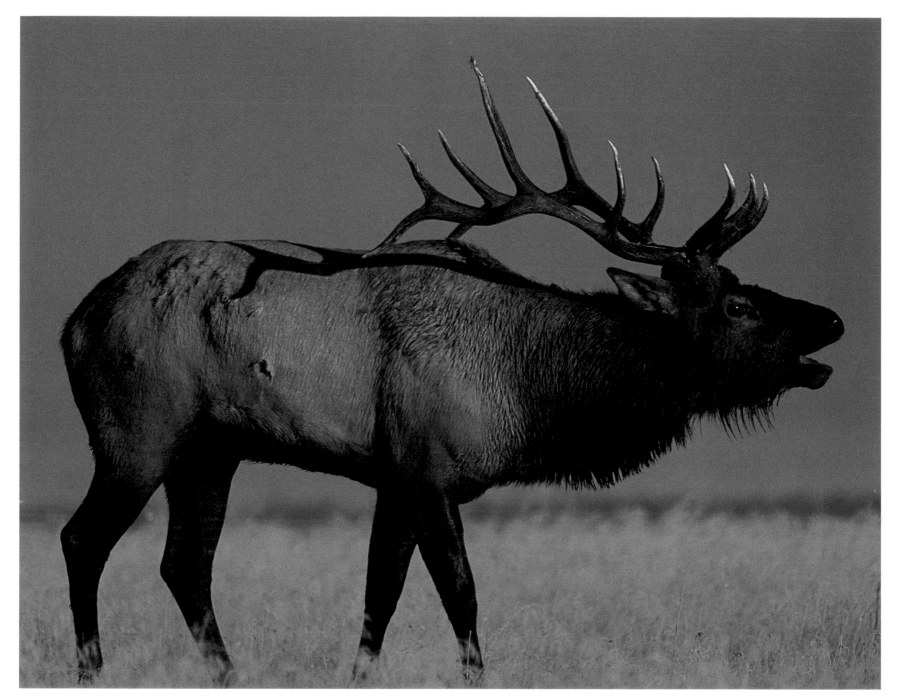

Bugling bull elk in frosted meadow. Opposite: Wolves—the elk's chief predators.

turf-ripping, dust-raising rutting of the bison, the largest and most powerful animal on the continent. A mature bull stands 6 ft. (1.8 m) at the shoulder and weighs up to 2,000 lb. (908 kg). Systematically exterminated by government policy, bison numbers in North America dropped to less than 1,000 animals in the late 1800's (down from an estimated 60,000,000 before European settlement). The species was saved from extinction by being protected in several areas, most notably Yellowstone National Park, where about 2,000 of these shaggy beasts roam today.

Although the Yellowstone region lacks the grandeur of other mountain parks, its geothermal features and abundant wildlife have made it

the best known refuge in the world. Geologic attractions include giant geysers, hot springs, boiling rivers, steam vents, mud volcanoes, paintpots, travertine ramparts, multi-hued thermal pools, craters, petrified wood, magnificent waterfalls, and the largest mountain lake on the continent. Most of Yellowstone's 2,000,000 acres are spread over a rolling volcanic plateau of coniferous forests and prairies—ideal habitat for moose, bison, mule deer, bighorn sheep, and large herds of elk (20,000 during the summer). These herbivores provide sustenance for grizzly bears, coyotes, and wolves, making Yellowstone a premier destination for those wishing to observe the natural behavior of these large carnivores in an open landscape. Widespread thermal springs and pools provide open water year-round and create a warm microclimate that attracts wildlife during harsh winter months.

Grand Teton is Yellowstone's sister park and more than makes up for Yellowstone's lack of classic mountain architecture. The Teton Range rises abruptly out of the Wyoming prairie, soaring 7,500 ft. (2,286 m) above the broad benches of the Snake River Valley. A persistent alignment of massive naked crags, snow-capped for much of the year, the Tetons dominate the surrounding landscape for hundreds of miles. Like Yellowstone, the starlit Teton landscape is serenaded regularly by the plaintive notes of resident wolf packs, re-introduced in 1995 after two decades of study. The marshes and backwaters of the Snake River comprise one of the most popular moose-watching locales in North America, especially during the autumn rut. The splendor of the central Rocky Mountains is not limited to these three parks but can be experienced in less crowded settings throughout the region.

One of these is Idaho's Sawtooth National Recreation Area, which boasts thousands of wilderness acres of rolling prairies, uplands, mountain lakes, and a spiny range of impressive peaks—the Sawtooth Range. Another region not to be missed is dominated by Montana's Beartooth Mountains, a collection of brittle escarpments, spear-like promontories, and glassy tarns second only to the Grand Tetons in their rugged grandeur. This barren expanse of dizzying chasms and looming granite barricades is accessible by a paved route that winds and zigzags through miles of wind-riven alpine habitat. Another inspiring panorama of sheer ridges and soaring summits sparkling with glaciers is the Wind River Range, a majestic formation nestled in the roadless hinterland of west-central Wyoming. Hidden from highway travelers by foothills, this long, tumbling projection of snow-capped peaks can best be appreciated with the assistance of a helicopter or 4-wheel drive vehicle and a stout pair of hiking boots.

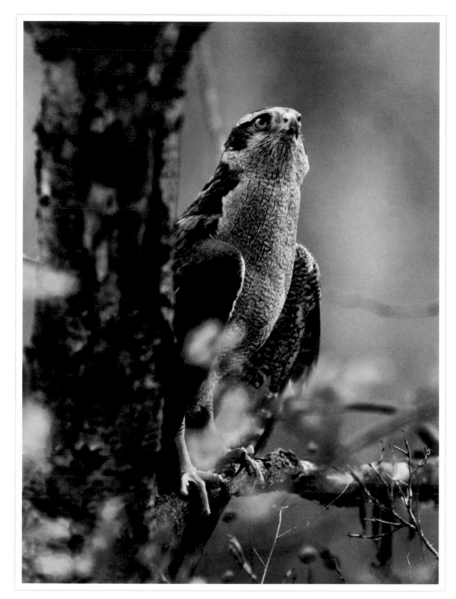

Northern Goshawk. Opposite: Summit Mountain, Glacier National Park, Montana.

The northern goshawk is the largest of the accipiter hawks, a group of woodland raptors known for swift, agile flight. They have short, rounded wings and long tails for making quick turns in the confines of the forest. The goshawk preys chiefly on birds and ducks, and occasionally takes mammals as large as hares and rabbits.

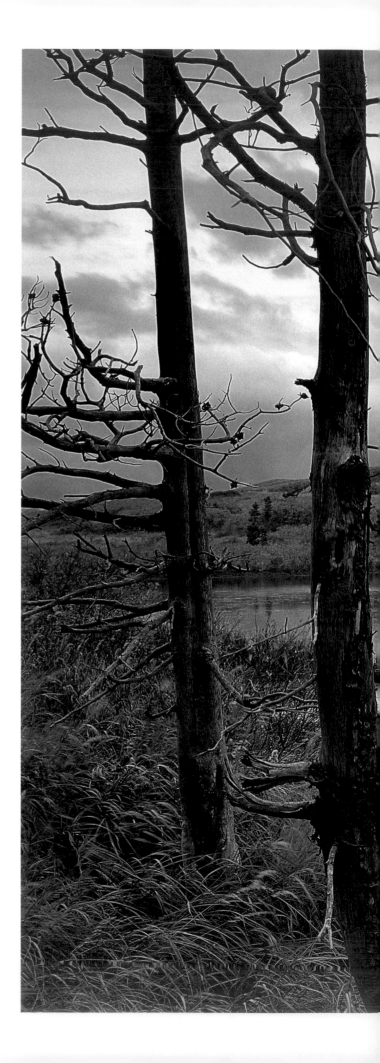

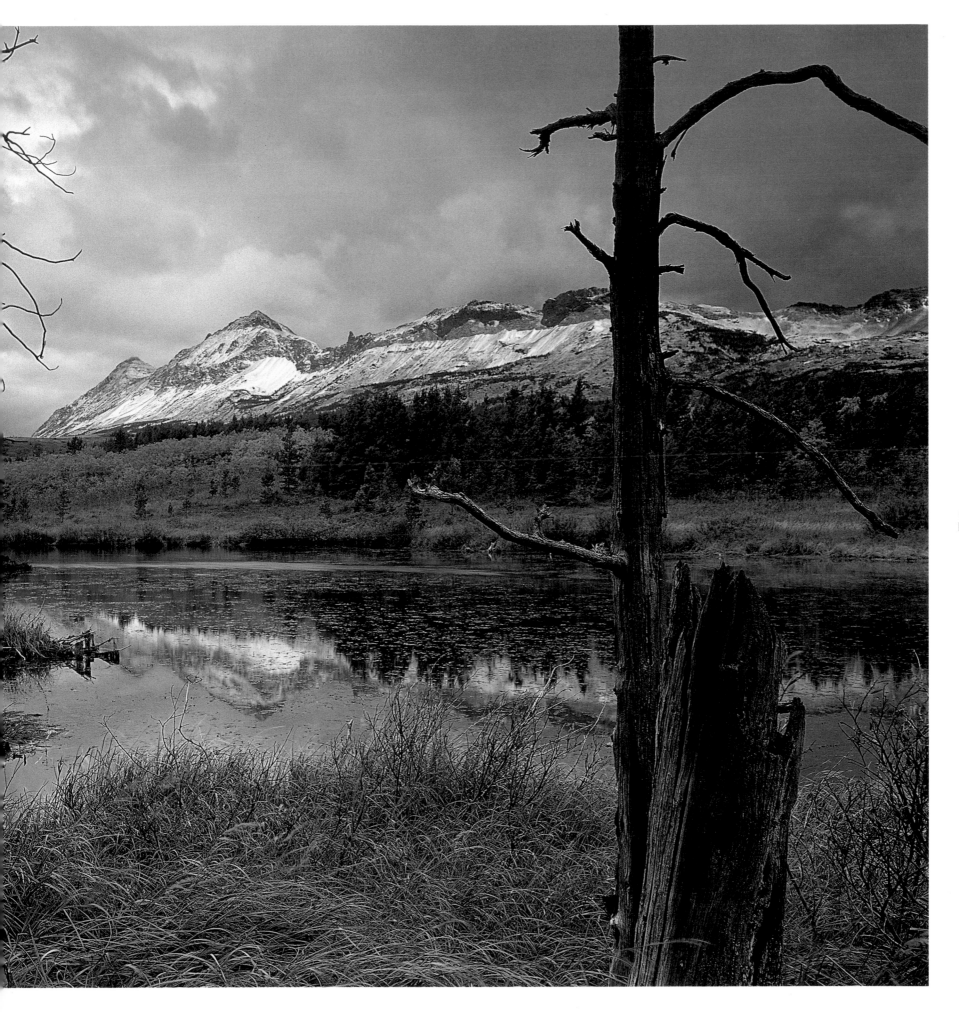

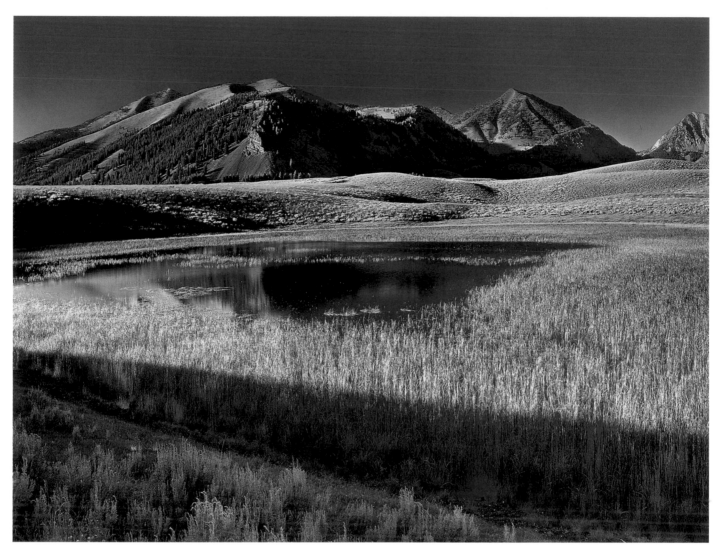

Boulder Mountains from Sawtooth National Recreation Area, Idaho.

The burrowing owl occupies prairies and other dry habitats, especially where ground squirrel and prairie dog burrows are numerous. About the size of a robin, it has long thin legs and a short tail. Its call, a soft mournful *coo-coooo*, is heard during darkness and at dawn and dusk. The burrowing owl begins to hunt at twilight, hovering and fluttering silently over meadows, searching for small rodents, crickets, grasshoppers, beetles, and other large insects. It snatches moths, dragonflies, and even bats from the air. The owl lays as many as ten eggs in an abandoned rodent burrow. When the young are hatched and nearly ready to leave the nest, they stand about the entrance curiously watching their surroundings. Should a predator threaten, they file below, emitting alarm calls that mimic the warning of a rattlesnake.

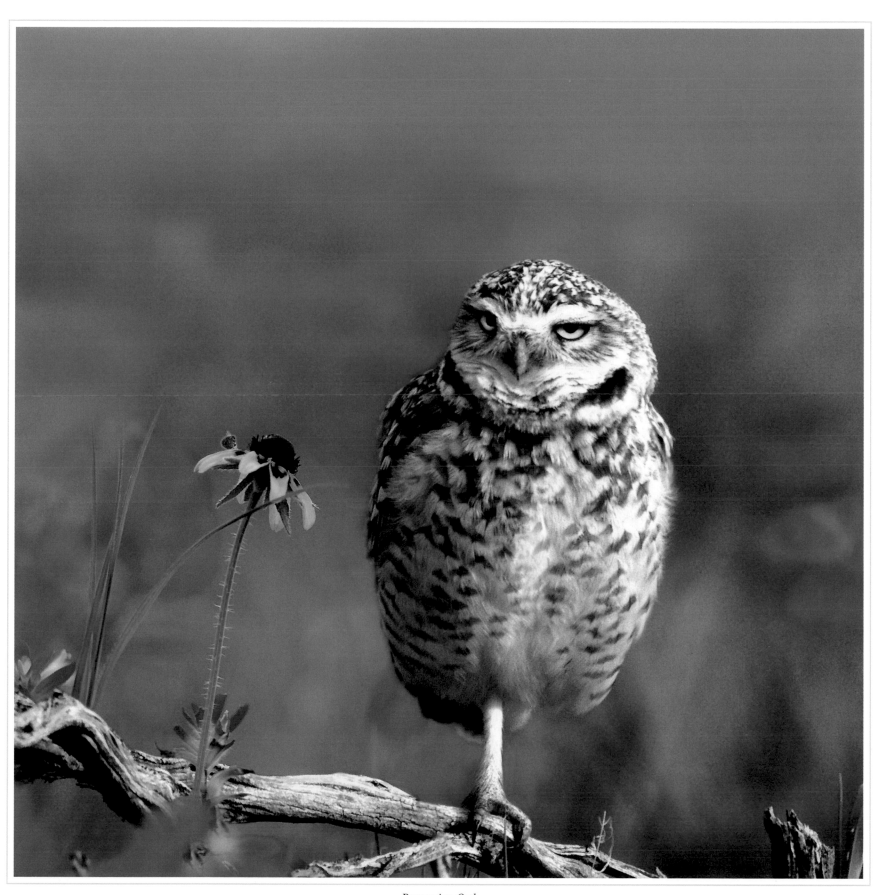

Burrowing Owl.

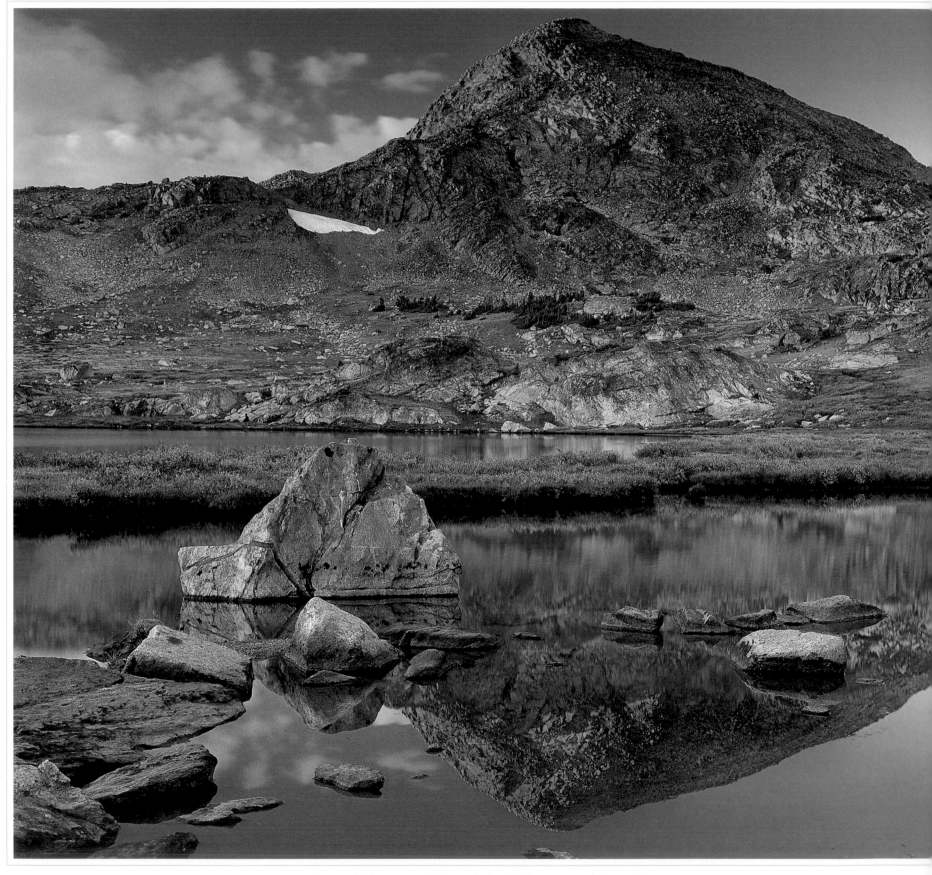

Beartooth Mountains and Frozen Lake, Shoshone National Forest, Wyoming.

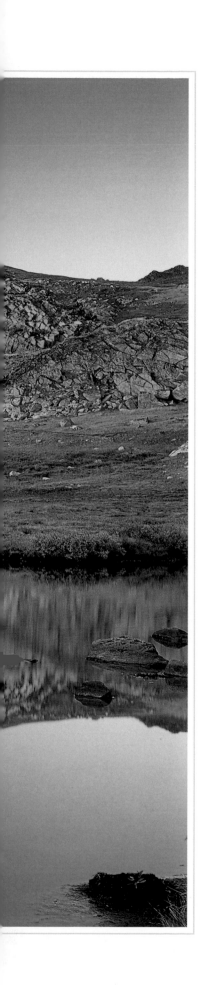

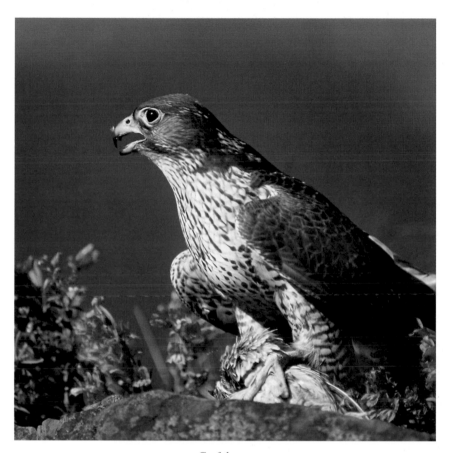

Gyrfalcon

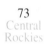

Moose calves weigh about 30 lb. (13.6 kg) when born and are awkward and wobbly on their feet for the first two weeks of life. By the end of the third week, the calves have doubled their weight and follow their mothers easily, even swimming across lakes. Mothers are protective of their young, charging and striking at intruders with their powerful front hooves. Moose are primarily browsers, stripping leaves and twigs from shrubs and trees. During summer, they feed on the aquatic plants of marshes and lake shallows.

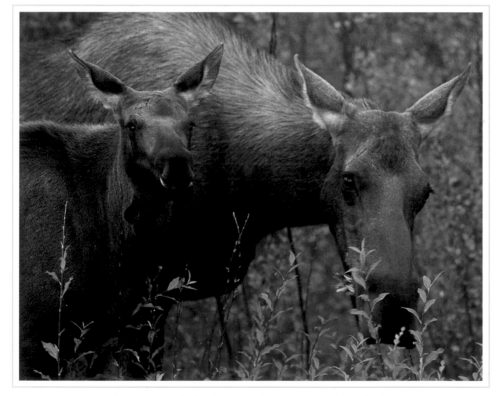

Moose cow and calf. Opposite: Teton Range at Schwabacher Landing, Grand Teton National Park, Wyoming.

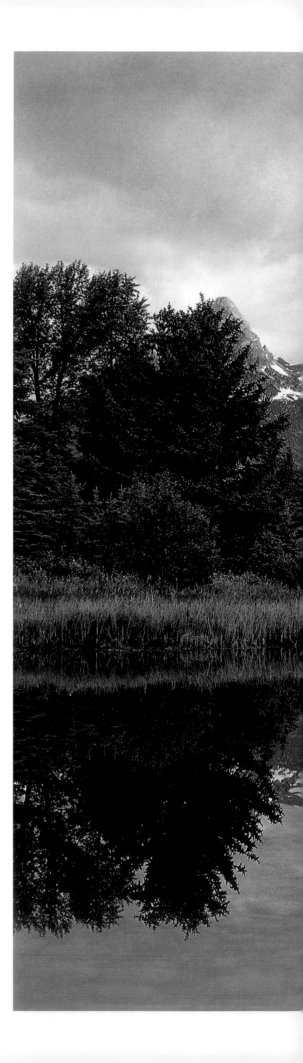

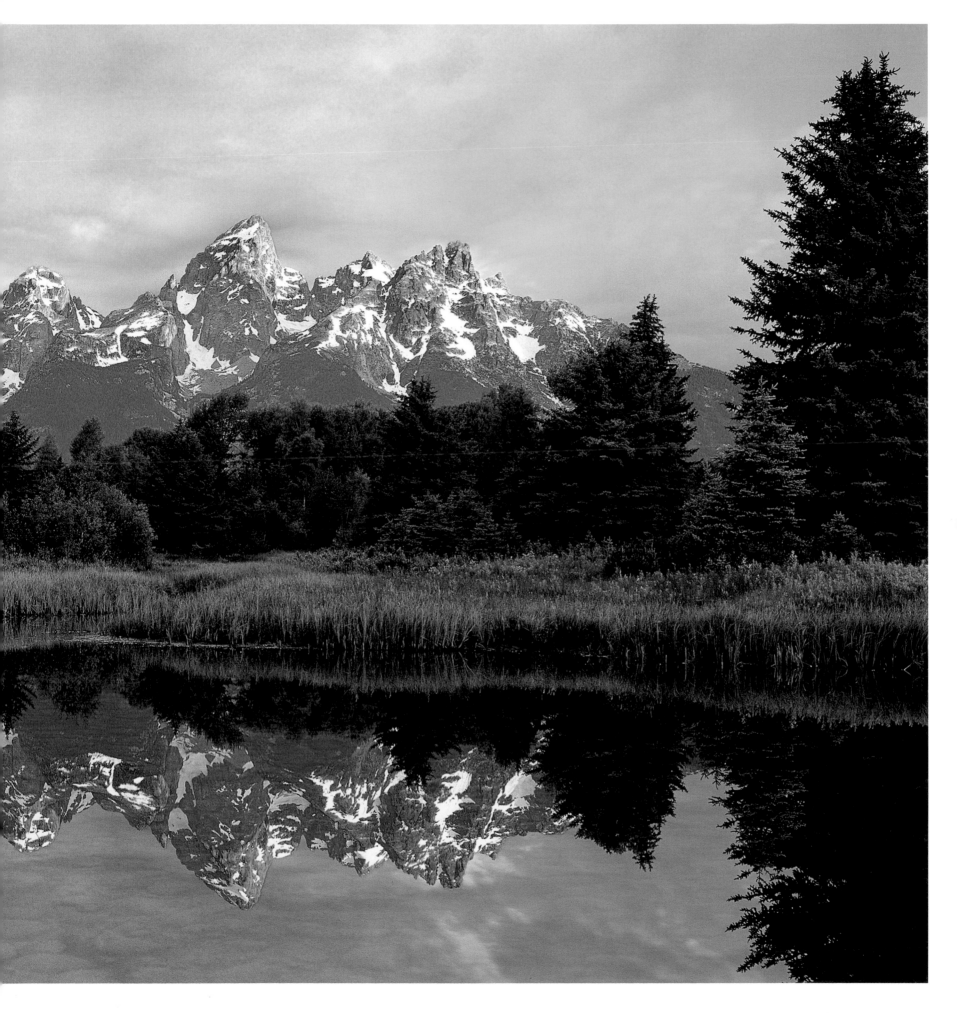

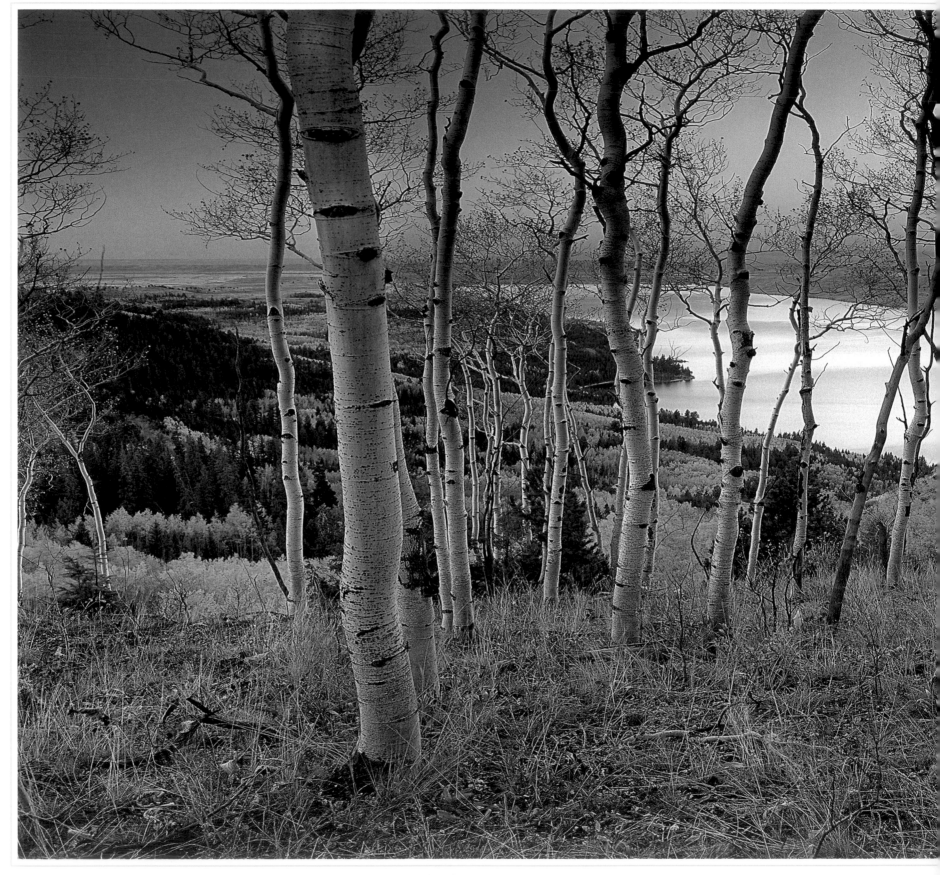

Fremont Lake and Bridger-Teton National Forest, Wyoming.

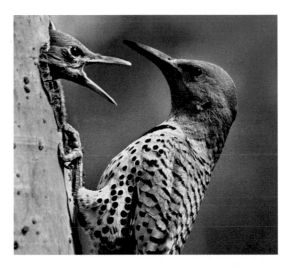

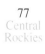

*Northern flicker (top) and red-naped sapsucker
(bottom) at nest holes in aspen trees.*

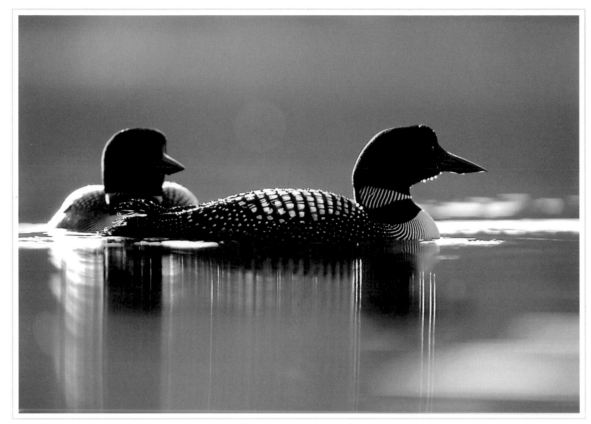

Common loons. Opposite: Cathedral Group, Grand Teton National Park, Wyoming.

The common loon breeds on mountain lakes in northern Montana and Idaho and in Canada wherever the water is deep enough to accommodate its laborious take-off—a wing-beating, foot-slapping run across the water that often takes more 100 yds. (91 m). Unlike the air-filled bones of other birds. the loon's skeleton is dense and solid, making it easier to submerge and swim under water. The loon pursues the swiftest fish to depths of 200 ft. (60 m).

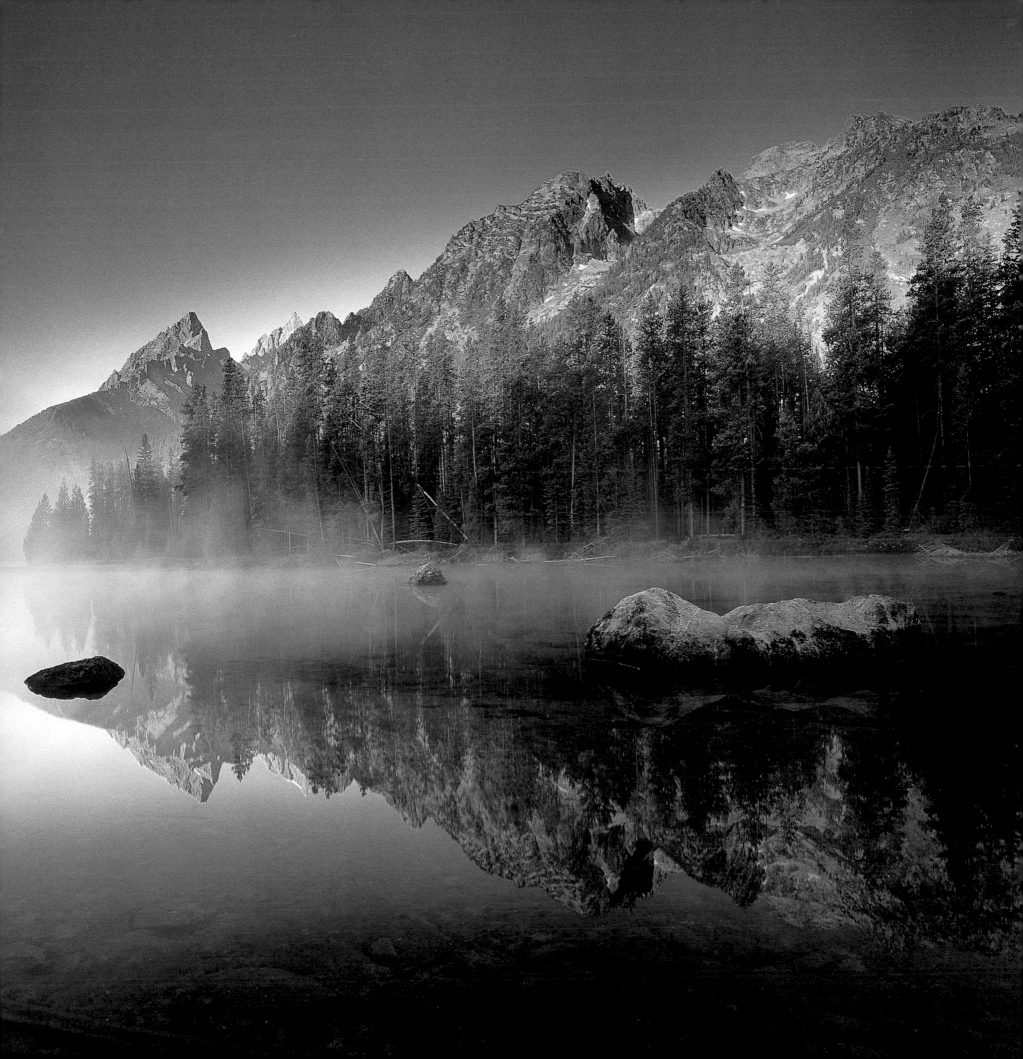

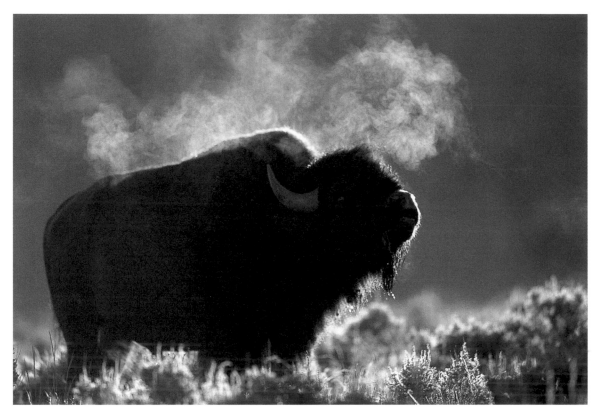

Bison bull.

Its massive, humped shoulders standing taller than a man, the bull bison weighs up to 2,000 lb. (908 kg). Before Europeans arrived in North America, an estimated 50 million bison roamed the continent's lush grasslands. With its heavy head slung low for easy grazing and a thick, shaggy coat to protect it from blizzards, the bison was ideally suited to this environment. The vast, wandering herds were followed by a host of predators—giant plains grizzlies, prairie wolves, coyotes, and scavenging foxes. Today a few thousand bison survive, mostly in protected, western mountain parks like Yellowstone.

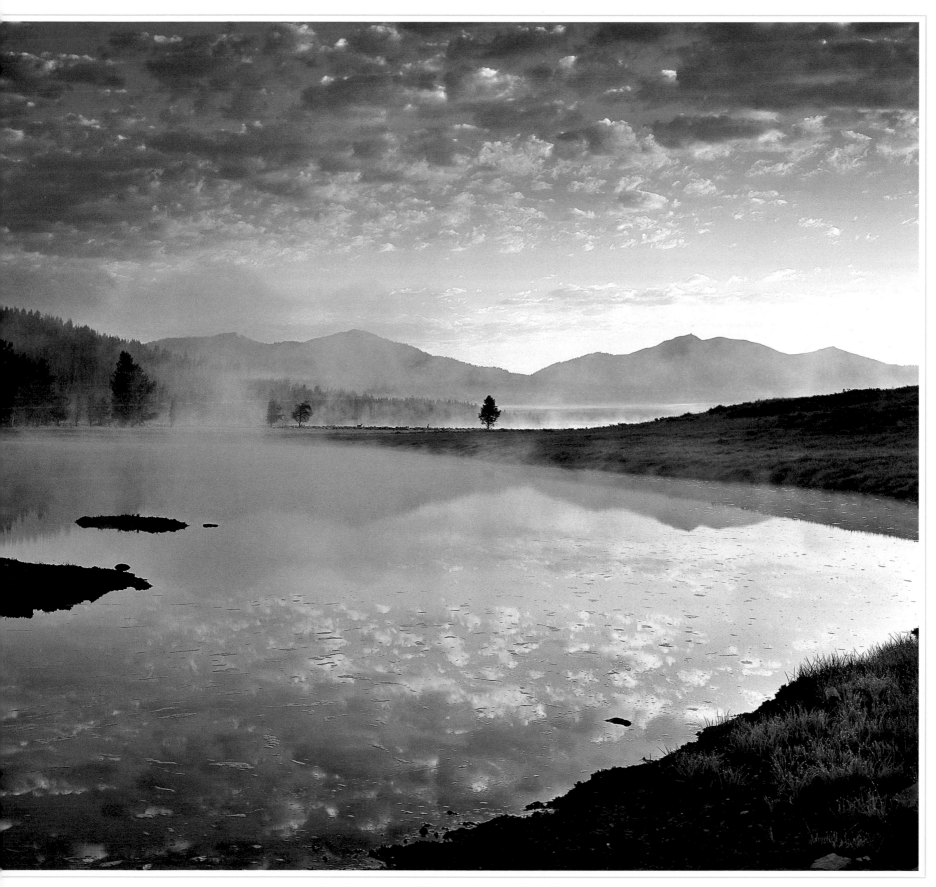

Alum Creek at dawn, Yellowstone National Park, Wyoming

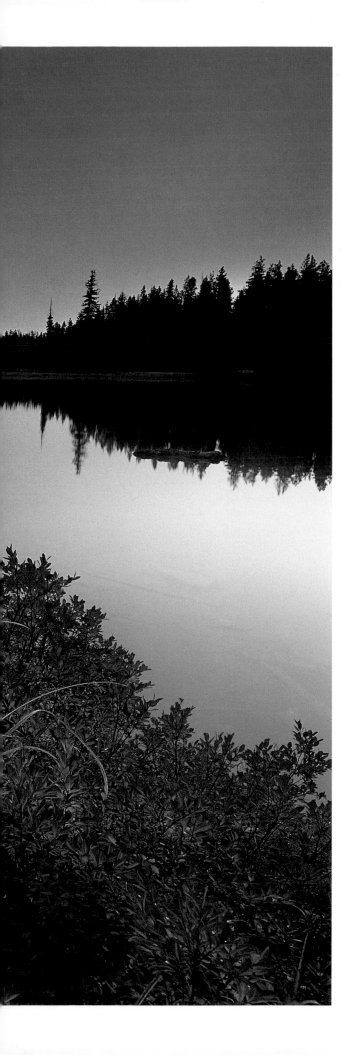

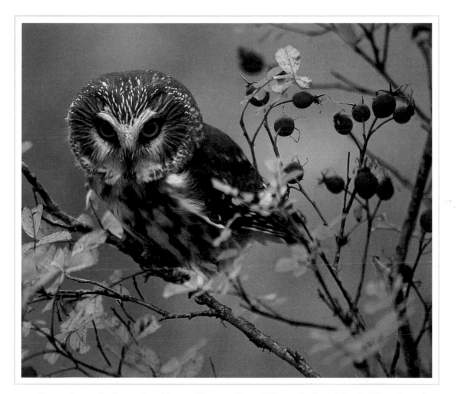

Saw-whet owl. Opposite: Mount Moran, Grand Teton National Park, Wyoming.

Only 7 in. (18 cm) long with a wingspan of less than 20 in. (50 cm), the saw-whet owl is a small nocturnal predator that feeds mainly on shrews and deer mice. The presence of this owl, like many other nocturnal birds is generally established by its call, a monotonously repeated, single-note whistle during the breeding season and a raspy utterance at other times.

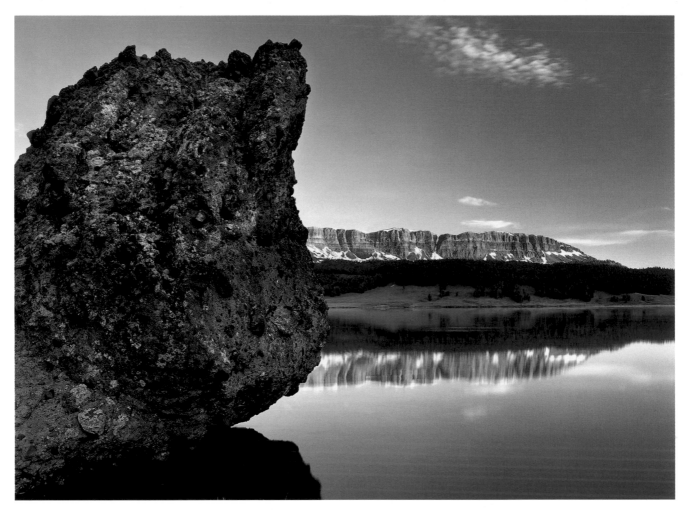

Breccia Cliffs reflected in Brooks Lake, Wyoming.

The bobcat is a silent, solitary stalker of small game. Snowshoe hares, cottontail rabbits, mice, and rats are its common prey, but bobcats also have been known to take domestic lambs, poultry, porcupines, muskrats, beavers, turtles, and even great blue herons. Bobcat kittens are born in the spring, usually in litters of three. The young are covered with woolly fur at birth and generally are fed by both parents. They stay with the mother until midwinter. The bobcat is able to adapt to a variety of habitats—swamps, regrowing forests, and even city woodlots. Unlike its cousin, the lynx, it has managed to sustain its population in spite of human destruction of its natural environment.

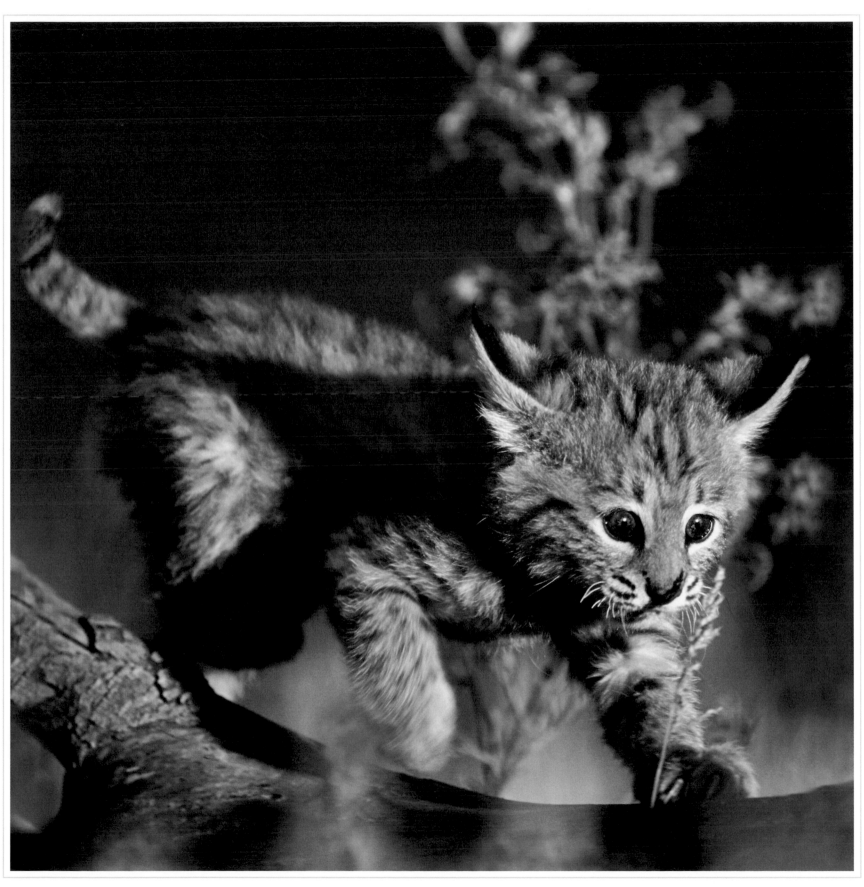

Bobcat kitten.

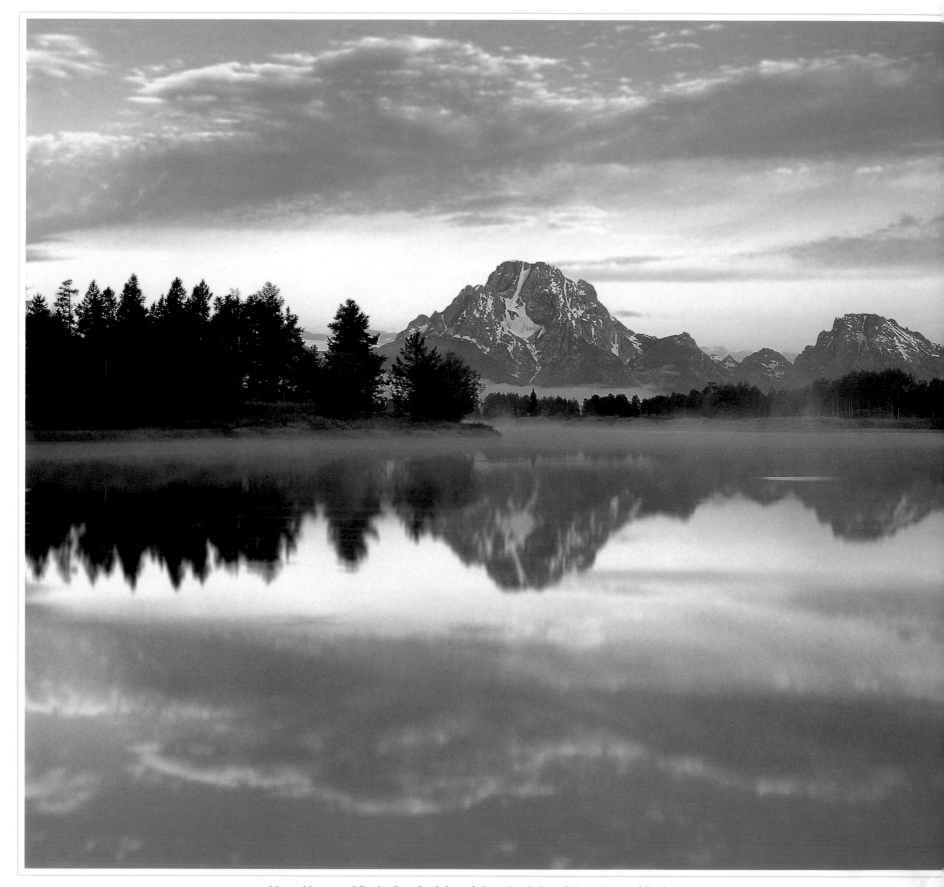

Mount Moran and Eagles Rest Peak from Oxbow Bend, Grand Teton National Park, Wyoming.

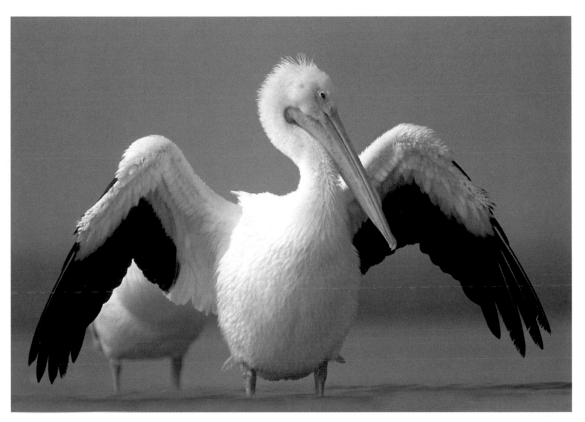

White pelican drying wings—a common sight at Oxbow Bend.

With a wingspan of nearly 10 ft. (3 m) and a length exceeding 5 ft. (2.5 m), the white pelican is one of the largest birds in North America. Despite its size, it flies buoyantly, taking off from water easily with a few strokes of its powerful wings and big, paddle-like feet. It is easily identified and distinguished from swans by its massive orange bill (topped with a knob during the breeding season) and black primary wing feathers shown during flight. In the Rocky Mountain region, white pelicans breed at lower elevations on small islands of lakes (including Yellowstone Lake) and large sloughs. Here their nests are protected from most terrestrial predators. They are often viewed fishing in groups on water courses where fish are plentiful, such as at Oxbow Bend in Grand Teton National Park.

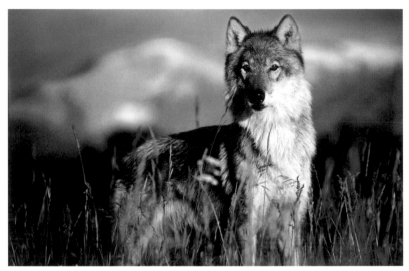

Wolf.

By the early 1900's, wolves were all but extinct in the 48 contiguous states except for northern Minnesota and Isle Royale in Michigan. A half century later, the Endangered Species Act was made law, requiring that federal agencies re-establish species that had disappeared from their natural ranges. As a result, wolves were successfully re-introduced to both Yellowstone and Grand Teton National Parks in the late 1990's with the import of 14 wild wolves from western Canada. By the end of the century, more than 100 of these predators were known to be thriving. The open terrain and high vantage points of the parks have made wolf-watching an entertaining pastime for tens of thousands of park visitors. These mountain wolves prey mainly on small mammals, elk, and mule deer, but they have also succeeded in killing moose, bison, and pronghorn antelope in Yellowstone.

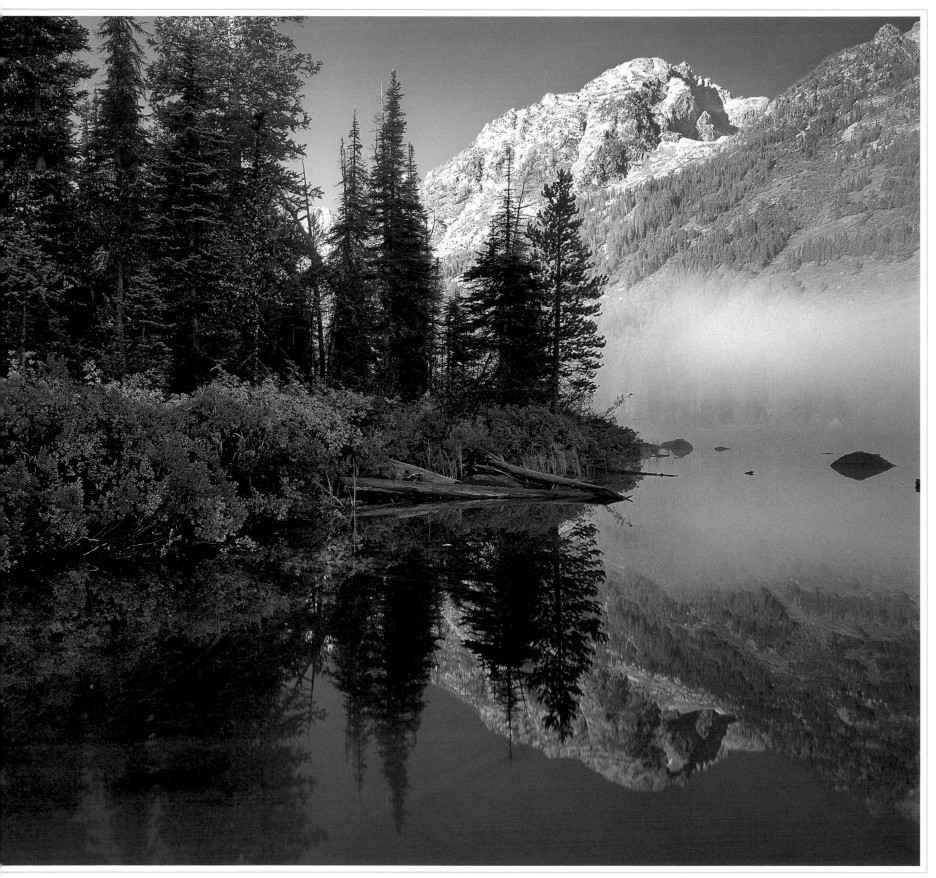

Teewinot Mountain, Grand Teton National Park, Wyoming.

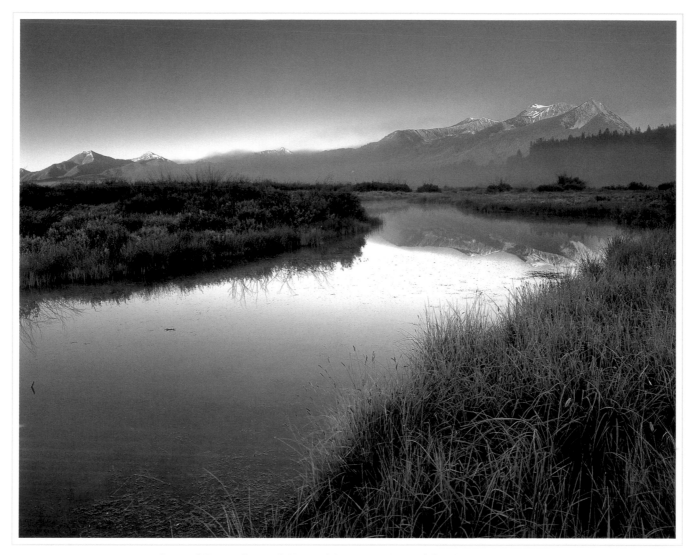

Sawtooth Range, Sawtooth National Recreation Area, Idaho. Opposite: Moose

The velvet covering of the moose's summer
antlers is rubbed off on shrubs and small trees. By autumn the antlers develop into rock-hard
structures larger than those of any other member of the deer family. During the rutting season, the
bulls attract females by trotting about their territories, thrashing the vegetation with their antlers,
and rolling in mud wallows sprinkled with their own urine.

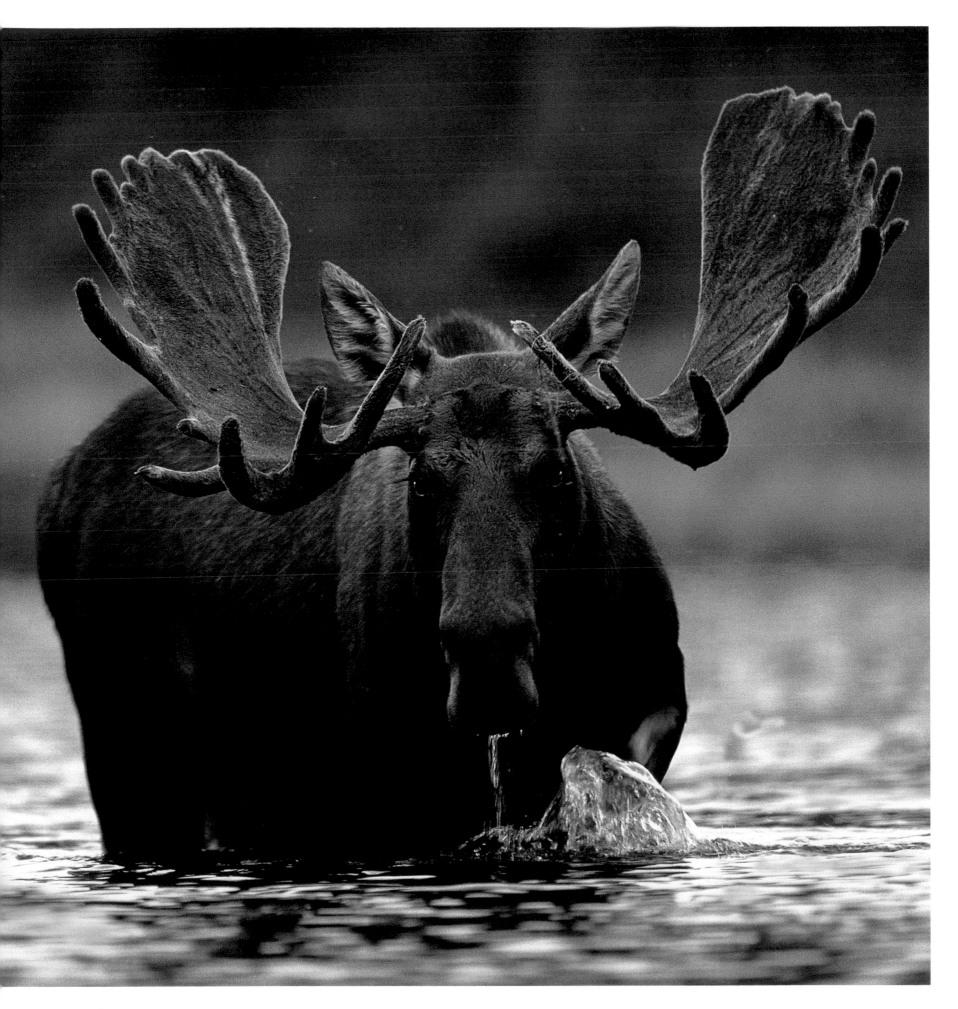

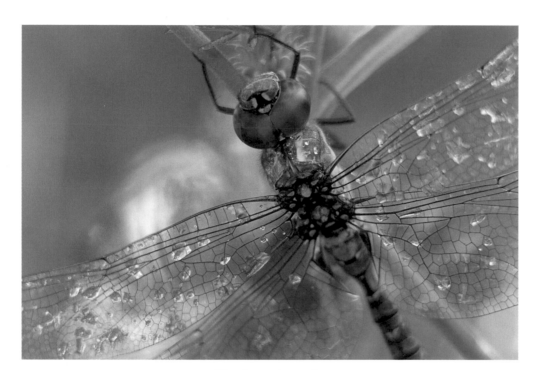

Blue darner dragonfly.

Aside from blackflies and mosquitos, dragonflies are the insects most likely to get your attention about mountain lakes and ponds. They are small but efficient predators, eating great numbers of other insects. Missing little that moves, their enormous, bulging, compound eyes are mounted on a freely rotating head. Their legs hang basket-like beneath the strong, cutting mouthparts, ready to entrap and hold firm an unwary midge, mosquito, or fly while it is being devoured. The four powerful, net-veined wings move independently, enabling the dragonfly to hover and fly forward and backward at great speed. Despite their fearsome appearance, dragonflies are harmless to humans.

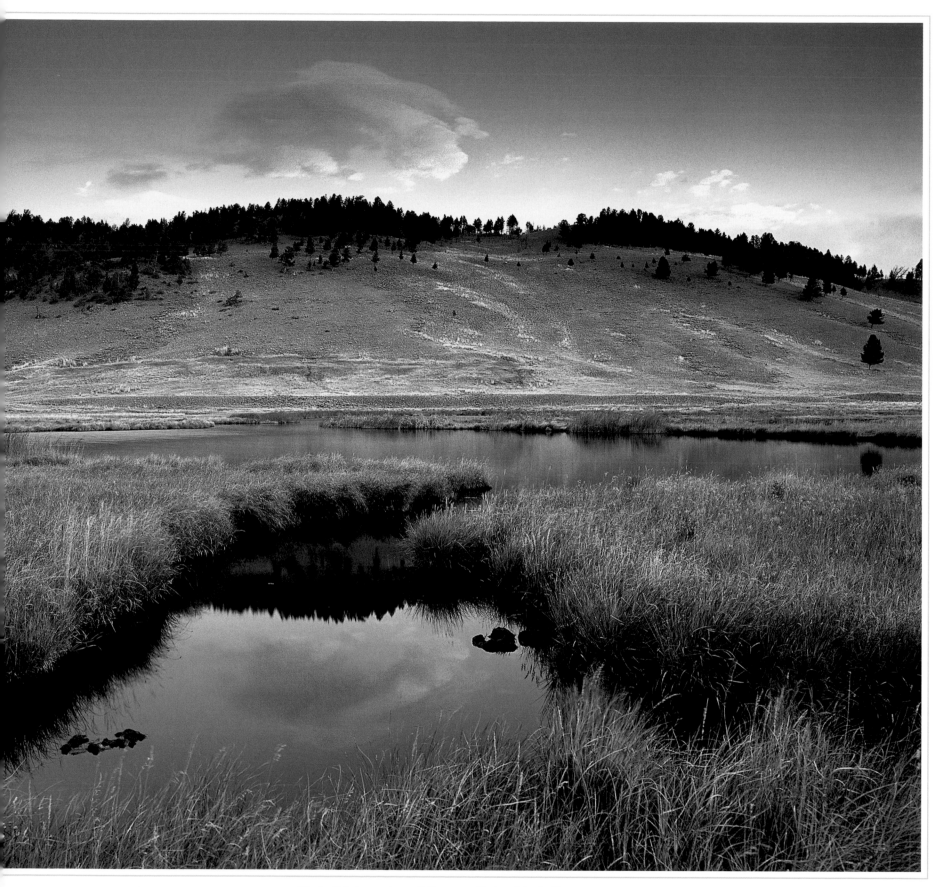

Blacktail Lakes at dawn, Yellowstone National Park, Wyoming.

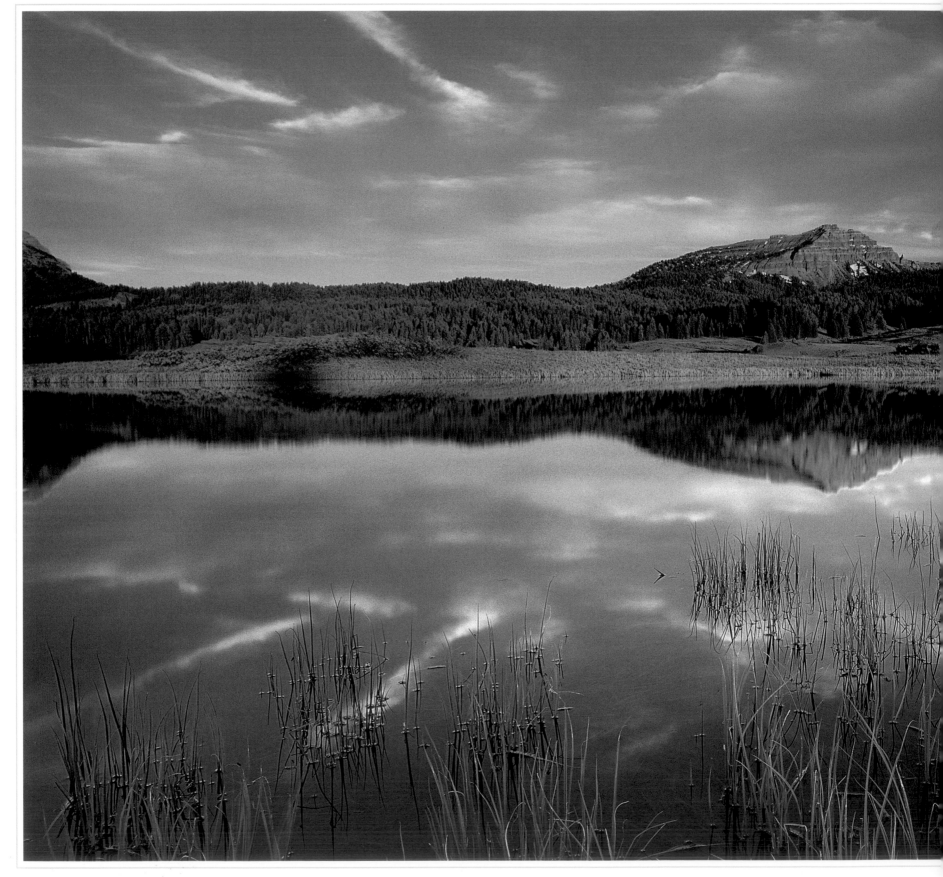

Tripod Peak at Togwotee Pass, Wyoming.

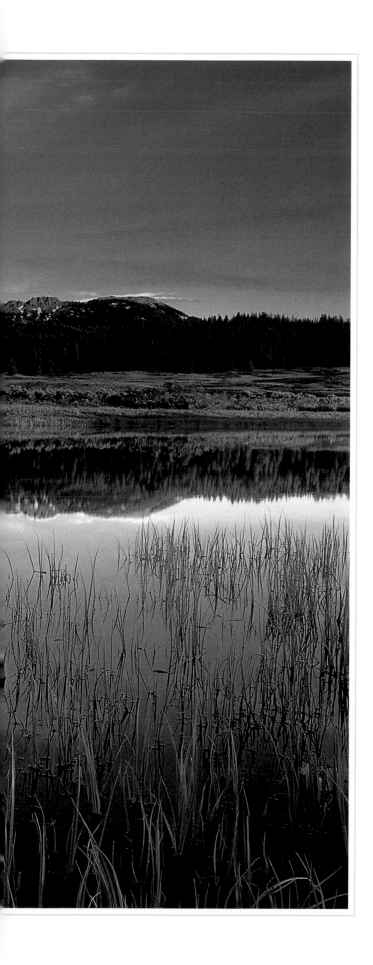

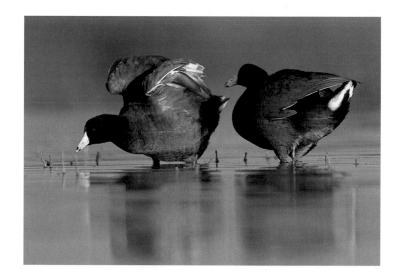

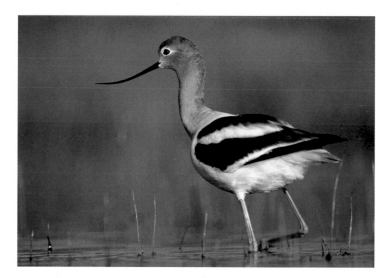

Top: American coots courting. Bottom: American avocet.

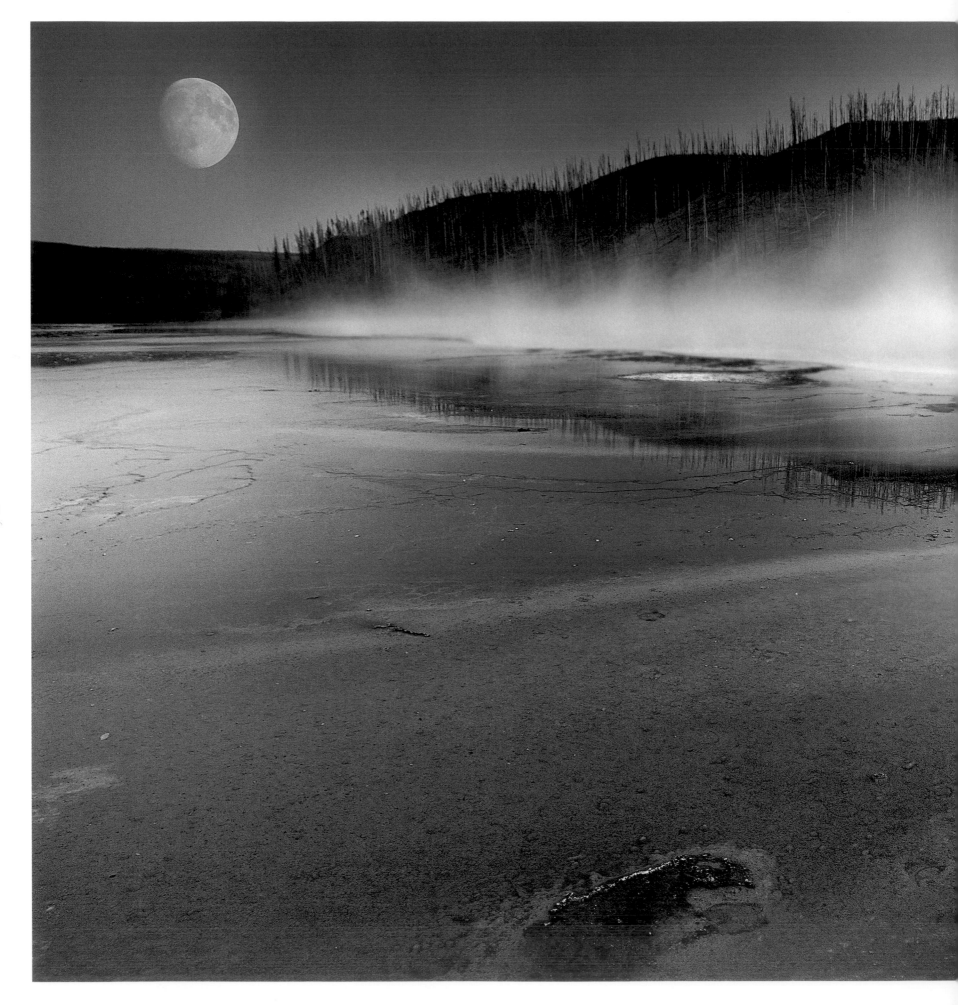

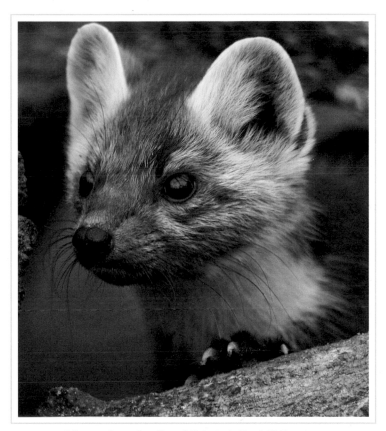

Marten. Opposite: Grand Prismatic Pool, Yellowstone National Park, Wyoming.

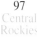

The marten, a high-energy member of the weasel family, is a typical denizen of coniferous mountain forests and is rarely seen in other types of habitat. Although superbly adapted to life in the treetops, the marten spends a lot of time on the ground, rambling about the debris and close vegetation of the forest floor. The intent of these mainly nocturnal forays is to catch mice and voles—rodents that account for about two-thirds of the marten's diet. Martens are curious and commonly follow an inviting scent into wilderness campsites and cabins. Their boldness makes them susceptible to trapping, and tens of thousands are killed by fur traders every year.

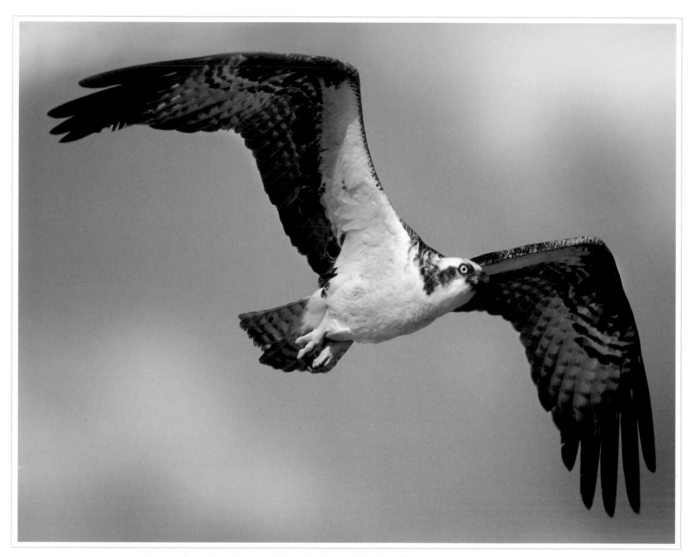

Osprey. Opposite: Garden Wall at McDonald Creek, Glacier National Park, Montana.

One of the most common birds of prey to be seen in the Rockies, the osprey inhabits forested regions near water. It usually watches over its favorite fishing holes from atop a snag or other prominent perch. Once prey is spotted, this large raptor (wingspan to 6 ft./1.8m) sails out over the victim, hovers, and then plummets, beak and talons foremost, to hit the water with a spectacular splash. Momentum propels the osprey below the surface momentarily, but it soon emerges with a wiggling fish in its talons, and struggles to free itself from the water, flapping its great wings heavily. Once airborne, the osprey adjusts the fish so that its head is pointed into the wind and flies to a snag to dismember its meal, or to the nest site to feed its young.

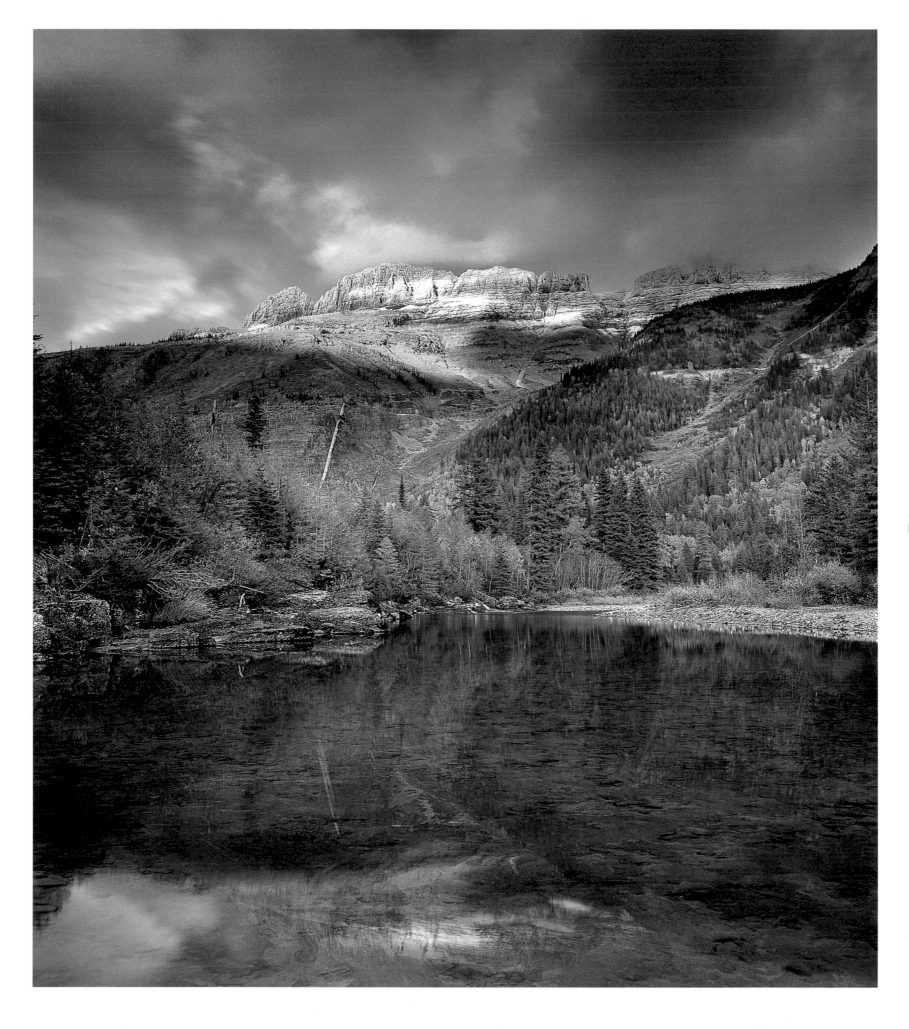

Southern Rockies

Colorado and New Mexico

All over the mountain I hear the song of birds, and the forest is filled with the perfume of spring flowers. Who can prevent me from enjoying these, which take from the long journey a little of its loneliness?

—Ho Chi Minh

Flashes of fur appear between the rocks that cover the mountainside in a loose, clattery mass. They progress down the slope toward the stream. The dab of fur hippity-hops across the water and disappears into lush herbs—paintbrushes, daisies, lupines, columbines. The flowers shudder and a fireweed blossom, seeping pink and magenta, topples and disappears. The fur ball comes back into view (fireweed attached), hippity-hops the stream, and addresses the slope. In a few minutes it is seen on a ledge far up the mountainside. It tucks the fireweed into a mound of drying vegetation beneath a boulder and scampers out onto a ledge. There it sits

for examination. It is the shape and size of a softball. The only append-age is a scarcely discernible head surmounted by shrunken, rabbit-like ears—a pika. Its head jerks convulsively and the mouth opens to expose a set of needle-like lower incisors. A nasal bleat simultaneously emanates from a jumble of boulders a few yards away. The performance is repeated with the same result.

Exhibiting its well-known talent for ventriloquism and an appetite for fresh herbs, the non-descript but entertaining pika is the signature species of the southern Rockies, the most spectacular and accessible mountains in North America. The dramatic mega-fauna of the north is scarce or missing here—wolf, grizzly, lynx, fisher, bison, mountain goat, caribou, moose—most as a result of human activity. Oddly, man has been both a blessing and a curse to lovers of the alpine. The discoveries of gold, silver, copper, and lead during the latter half of the nineteenth century led to road-building through high alpine passes on an unprecedented scale. The mines were exhausted and then abandoned, but the routes were later to usher in a commercial renaissance. The mountain backcountry of Colorado is riddled with byways, many of which are paved or graveled for the fam-ily sedan; others are suitable for travel only by 4-wheel drive vehicle. Resorts and back country outfitters have flourished, and the old Victo-rian mining towns have experienced renewed prosperity based of late on mountain recreationists—sightseers, nature-lovers, fishermen, hunters, backpackers, bikers, and skiers.

Colorado is the highest state in the United States, with more than 1000 mountains topping 10,000 ft. (3,048 m) and more than 50 peaks

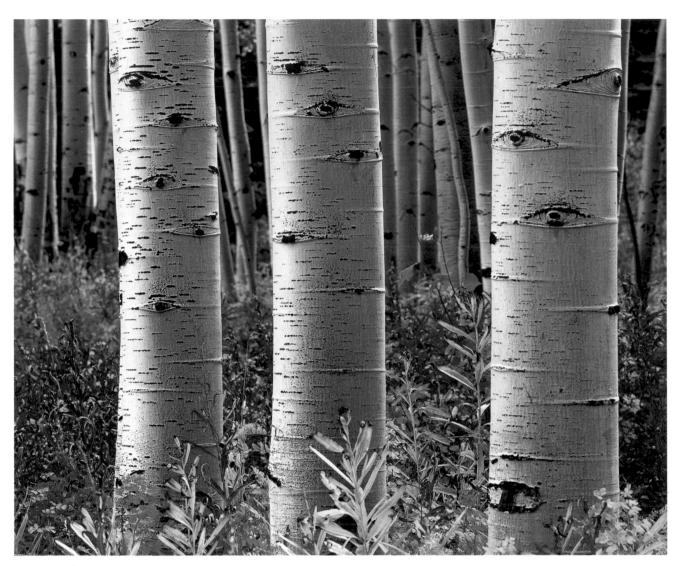

Aspens and fireweed near Aspen, Colorado. Opposite: Subalpine wildflowers at Yankee Boy Basin, Colorado.

above 14,000 ft. (4,267 m). These mountains burst out of the state's eastern prairies, rupturing and lifting these orange, brown, and buffy layers to form the colorful foothills of the Front Range. This lofty terrain is best appreciated in Rocky Mountain National Park, where well-planned roads shepherd the visitor through parklands, subalpine meadows, coniferous forests, and alpine tundra. In the autumn, the meadows at lower elevations reverberate with the bugling of elk and the drone of thousands of vehicles convening to witness the rutting spectacle.

The mountains of Colorado, interspersed by dry plateaus, flow westward from the prairies for 200 mi. (320 km), generating a storm-tossed, stony ocean of ragged crags, soaring pinnacles, plummeting chasms, and hatcheted canyons. The line-up of ranges and peaks is nearly legendary: the gigantic granite knobs of the Spanish Peaks; Mount Evans and its 28 mi. (45 km) of road that climb all the way to the 14,264 ft. (4,347 m) summit; the Maroon Bells, an enormous pair of blood-red "fourteeners" on the outskirts of Aspen; the cloud-brushed

fairyland of the Sawatch and Elk Ranges; and tucked away in the southwest corner of the state, perhaps the most beautiful area of all—the San Juan Range, a paradise of glacier-scoured peaks patched by wildflower-strewn meadows and bristly stands of aspen made lush and vigorous by summer monsoons.

In addition to the magnificent alpine formations, the intricate web of highways and jeep trails that make them accessible, and the many resort towns—Aspen, Vail, Breckenridge, Telluride, Ouray, Crested Butte, Santa Fe, Taos—the southern Rockies are distinguished by a beautiful flora. The interior ranges in particular are suited for the growth of pure stands of trembling aspens of great size. The sculpted, cream-colored trunks (up to 2 ft./0.6 m in diameter) and shimmering foliage, minty emerald in summer and glinting gold and bronze in autumn, decorate entire slopes. Unlike evergreen forests, the open canopy of an aspen grove allows sunlight to enter and fuel the growth of a lush understory of shrubs and herbs. The result is ideal habitat for wildlife. The canopy, trunks, shrubs, and ground cover provide nesting habitat for scores of birds, from the powerful northern goshawk and great-horned owl to the red-naped sapsucker and blue grouse. Elk, mule deer, and white-tailed deer browse on aspen leaves and twigs. Porcupines nibble on the sweet inner bark and black bears ascend the canopy to munch on spring buds and catkins. Aspens grow side-by-side with another special tree of the southern Rockies—the blue spruce—resulting in a stunning mix of hues during autumn.

Another floral attraction is the wet wildflower meadows of the subalpine zone, unmatched in color (especially in the San Juan Mountains) elsewhere in the Rockies. By July the snows have receded and the vegetation surges to waist level and above. Blooms of every color and shape are sprinkled generously over the slopes—red paintbrushes, nodding blue columbines, azure lupines, purples penstemons, and dozens more that overwhelm the visual sense.

The Rockies trail off as they enter New Mexico and run the length of the state in sporadic bursts that are but a shadow of their northern glory. To be sure, the New Mexico portions of the Sangre de Christo Range have classic alpine configurations. Elsewhere the decline in stature is enlivened by attractive features of natural history. Flanked by the feeble ramparts of the Chupadera Mountains, the great migratory bird sanctuary at Bosque del Apache is winter home to tens of thousands of snow geese, sandhill cranes, and a handful of endangered whooping cranes. Of note also are the sparkling gypsum dunes of White Sands National Monument spread in undulating elegance against the backdrop of the San Andres Range, the colorful autumn spectacle of the maples in the Manzanos Mountains south of Albuquerque, and the hunting paradise of the Gila Wilderness encompassing the modest, rumpled contours of the Black, Mogollon, and Tularosa Ranges.

Twin Peaks at Upper Twin Lake, Colorado.

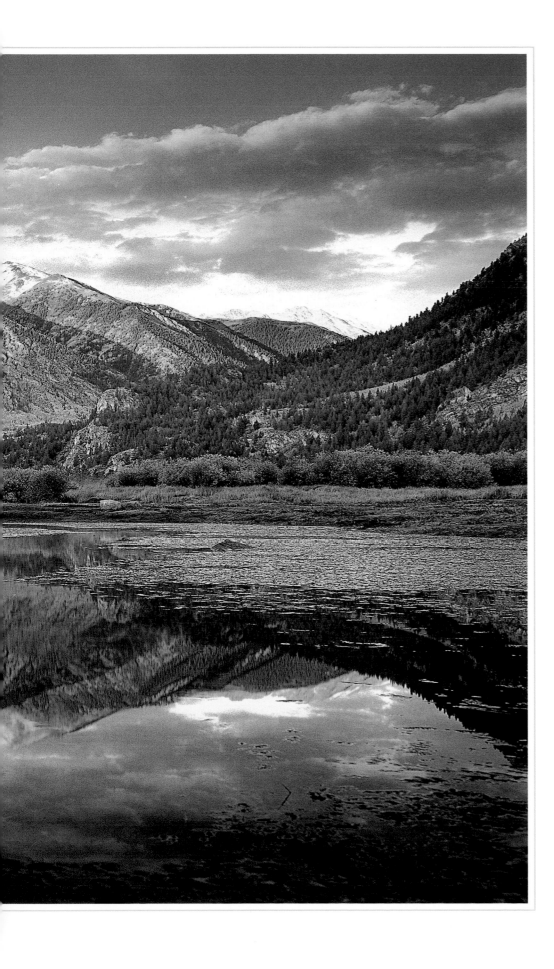

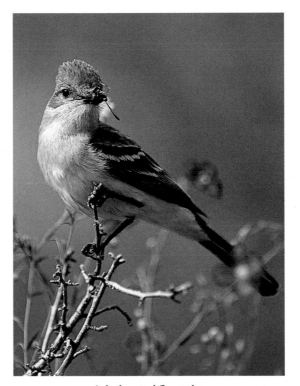

Ash-throated flycatcher.

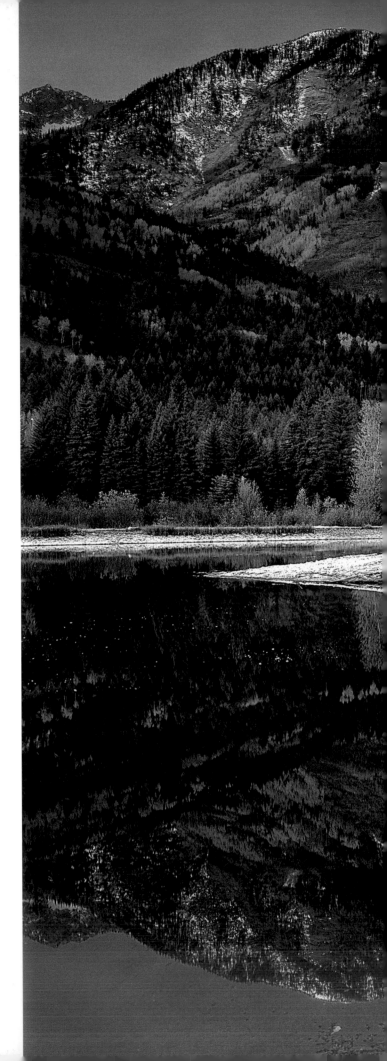

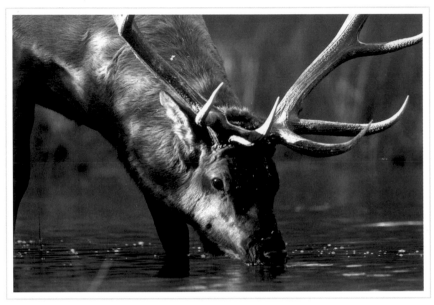

Bull elk. Opposite: Ragged Peak and Chair Mountain, Raggeds Wilderness, Colorado.

The autumn rut of the bull elk is one of the most dramatic and readily viewed wildlife events in the Rockies, especially in parks and refuges where the elk are not threatened by hunting. Twilight hours are best to observe a stag and his harem of cows as they assemble in open meadows to feed and socialize. While the cows graze, the stag bugles to attract more females and to answer the challenging notes of other bulls in adjacent territories. The stag is kept busy driving straying cows back into the herd. On the periphery, smaller bulls linger, hoping to mate with one of the cows while the dominant bull is preoccupied. When they approach a cow, they are driven off aggressively by the stag only to wander back a few minutes later. Occasionally two stags engage in combat, usually a shoving match of locked antlers, but occasionally the bulls rear up to batter one another with front hooves.

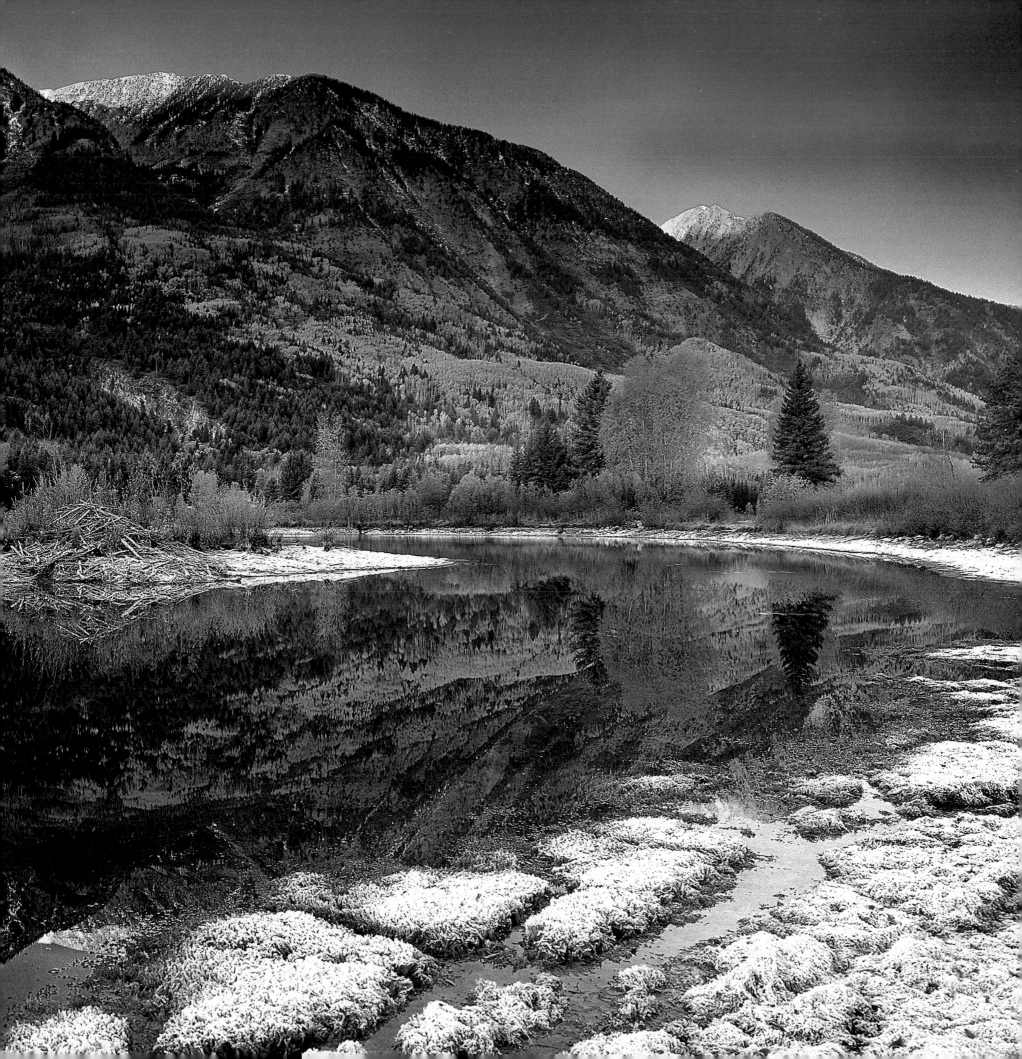

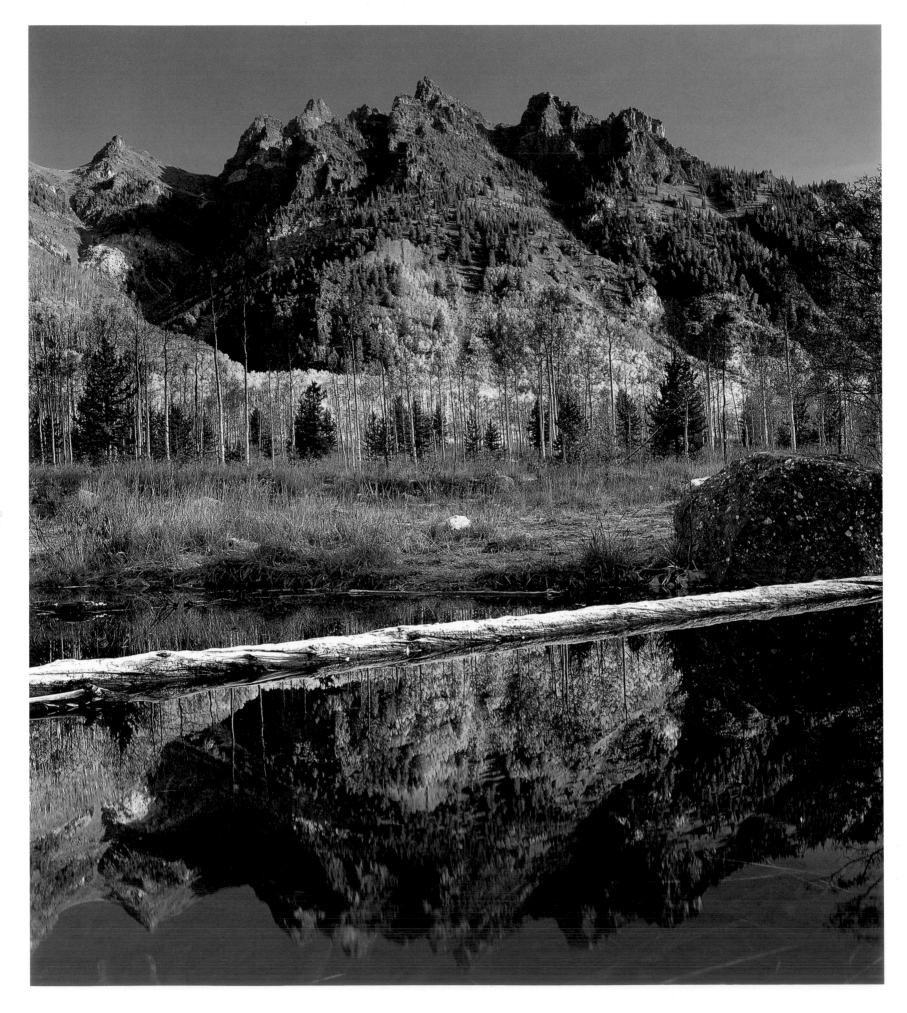

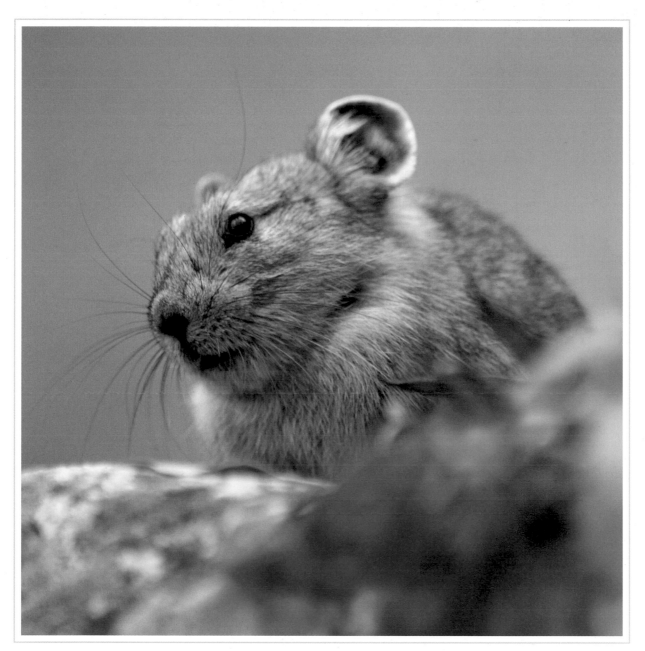

Pika. Opposite: Sievers Mountain, Maroon Bells-Snowmass Wilderness, Colorado.

When not sunning itself on a look-out rock, the pika forages in nearby meadows. It scurries and hops from one plant to another, clipping off tender shoots that are arranged crosswise in its jaws until the bundle's size merits a return trip to the avalanche of rocks and boulders that is its home territory. Here the diminutive load of hay is packed onto one of the stacks that the pika has built among the rockpile. The pika typically inhabits talus slopes above timberline, and when frosts of late summer attack the vegetation, it retreats to its burrow and hay stashes for the winter.

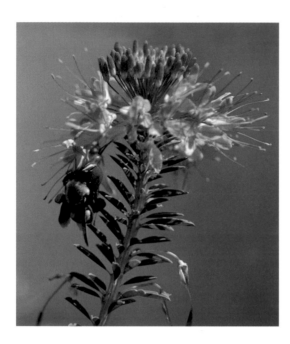

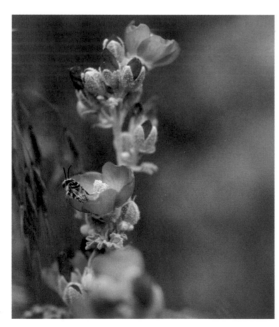

Top: Rocky Mountain bee flower.
Bottom: Scarlet globe mallow.

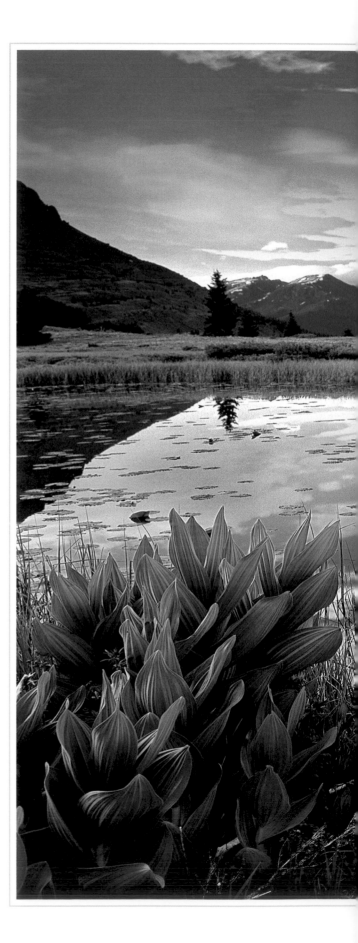

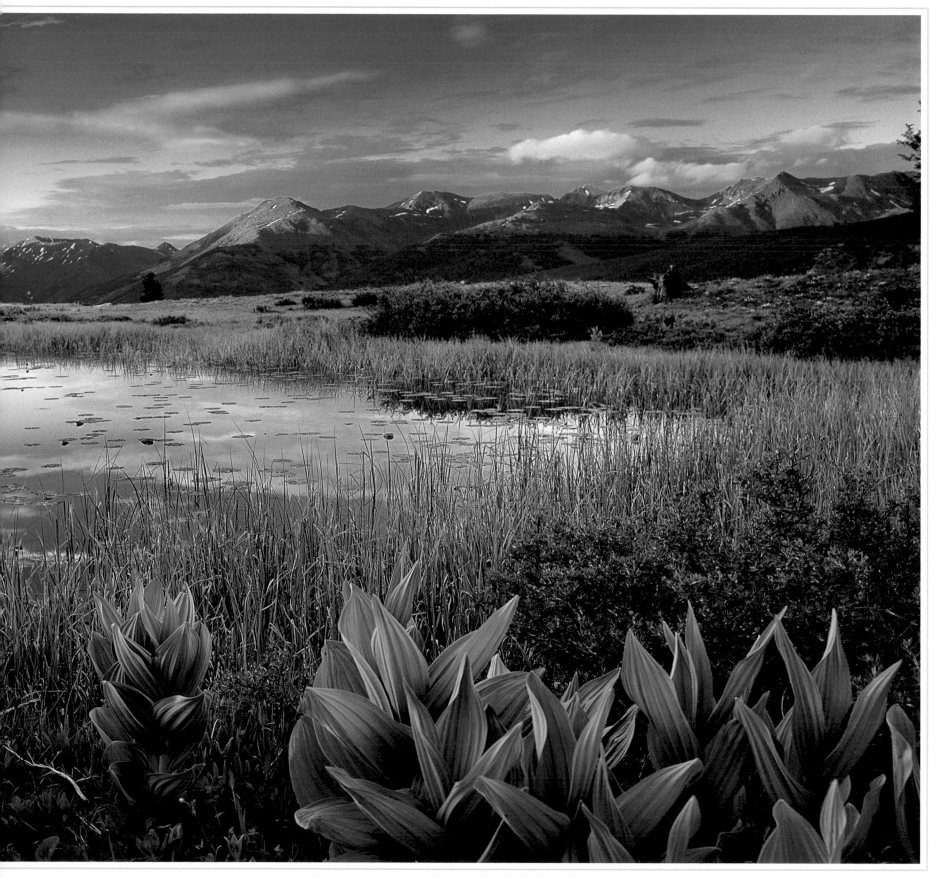

Grenadier Range, Weminuche Wilderness from Molas Pass, Colorado.

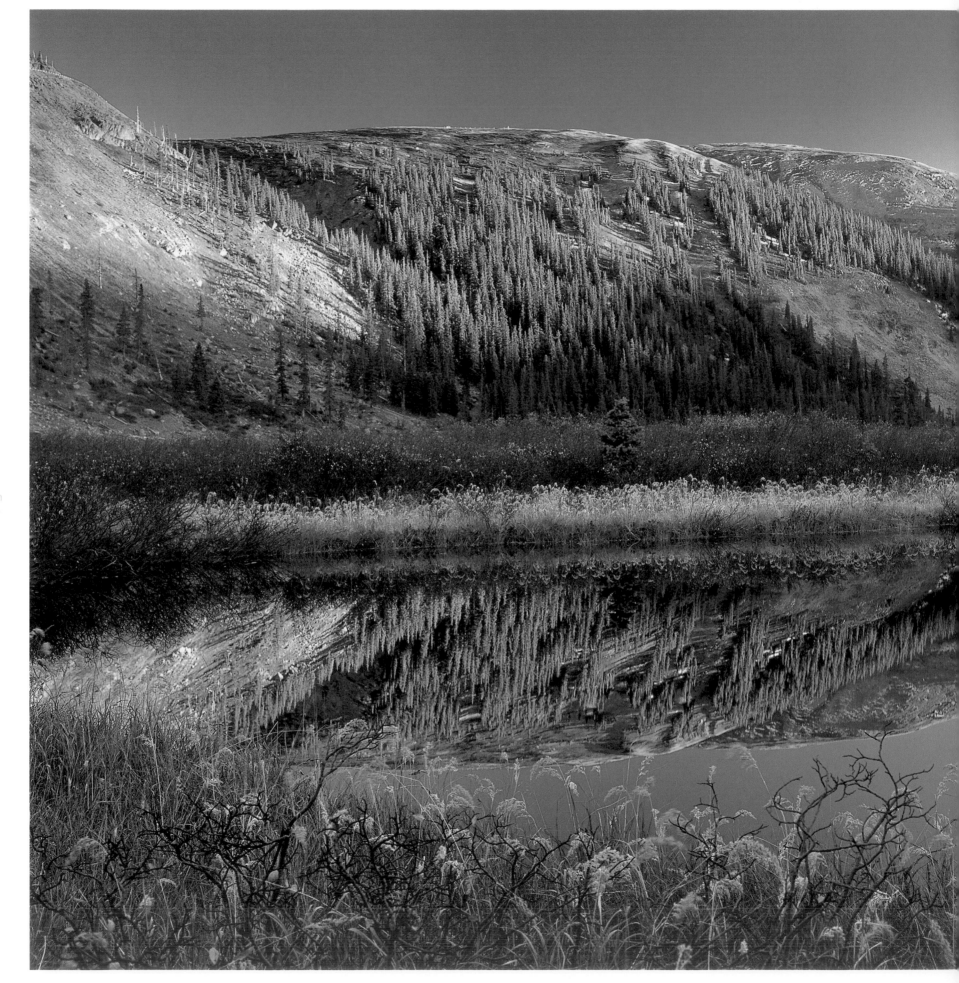

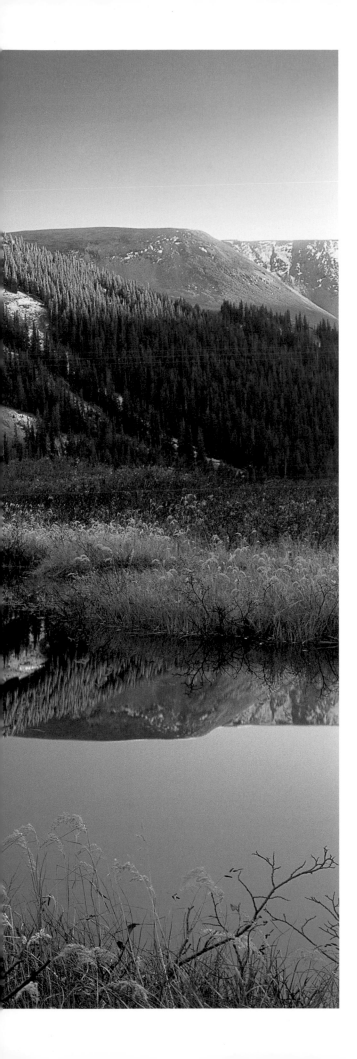

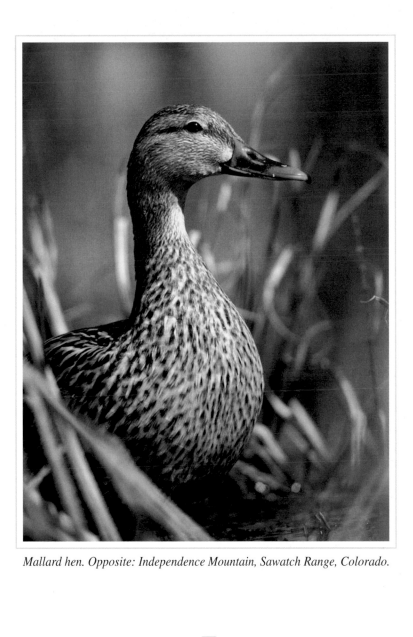

Mallard hen. Opposite: Independence Mountain, Sawatch Range, Colorado.

The mallard weaves its nest of grasses and reeds on the ground near lakes and marshes throughout the Rocky Mountain region. The hen lays about ten eggs and incubates them for a month. She sits silent and immobile atop the pile even when predators venture near, abandoning the hiding place in a vertical explosion of wings and body only at the last moment. After the young hatch, the hen leads them to the nearest water. Here they spend the summer feeding on a variety of seeds, pondweeds, insects, mollusks, and fish eggs.

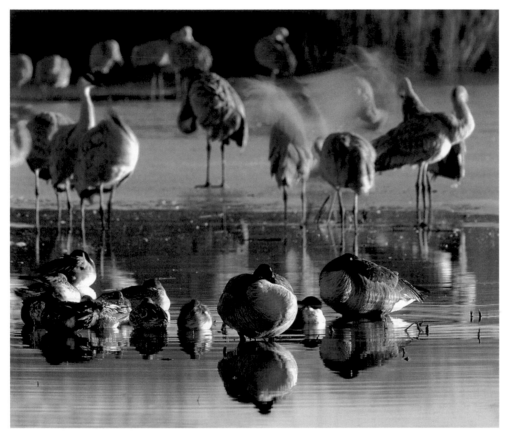

Waterfowl and sandhill cranes, Bosque del Apache National Wildlife Refuge, New Mexico.

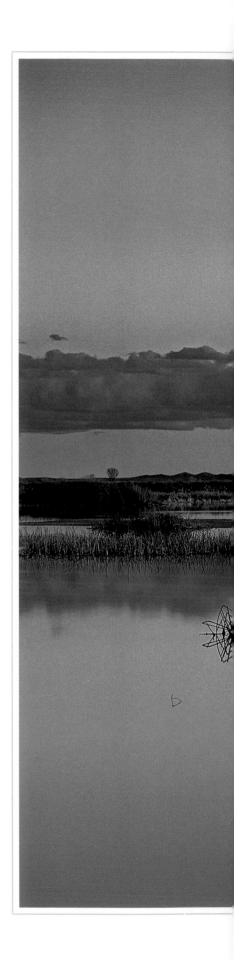

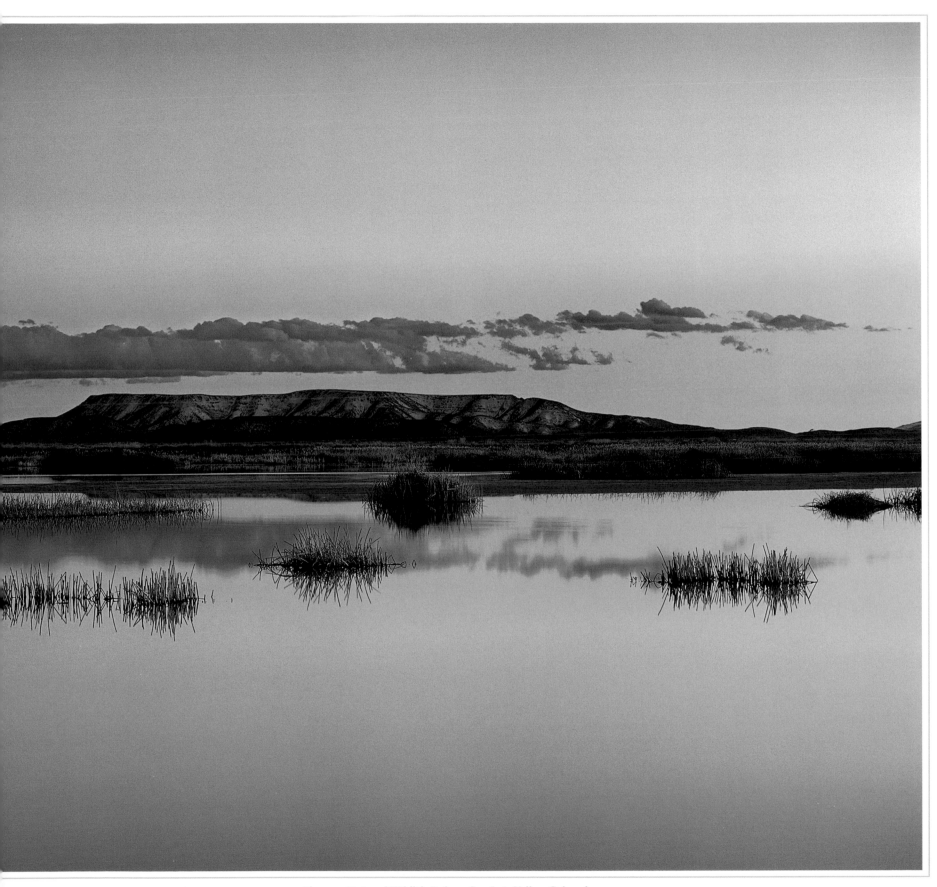

Alamosa National Wildlife Refuge, San Luis Valley, Colorado.

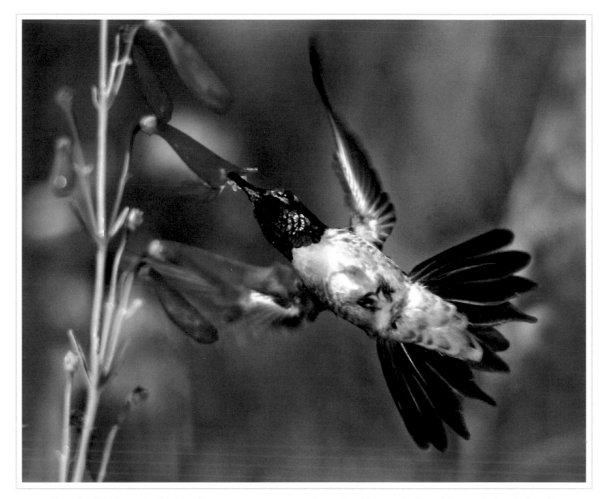

Broad-tailed hummingbird feeding at scarlet trumpet. Opposite: Maroon Bells at Maroon Lake, Colorado.

The broad-tailed hummingbird is common throughout the southern and central Rockies. Both sexes are metallic green above. The male boasts a rosy-red throat and white belly with green flanks while the female's throat is speckled and her flanks are cinnamon. In late spring and summer, broad-tailed hummingbirds are easily spotted in wildflower meadows as they zoom noisily about, hovering regularly at tubular blooms to draw nectar.

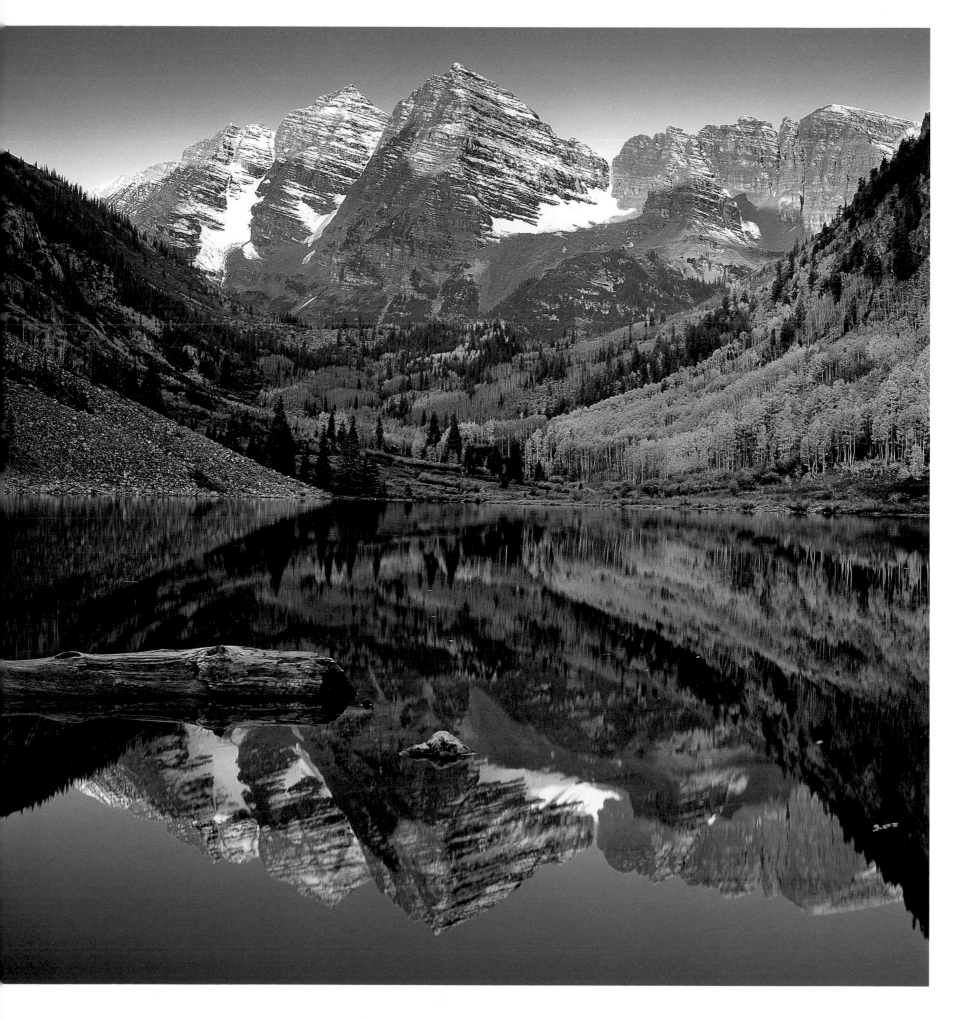

A solitary stalker of marshes and lake shallows, the great blue heron is the most common large wading bird of the Rocky Mountain region. It is most often seen poised, statue-like, over a pool of still water, peering into the depths for a fish, frog, or crayfish. It strikes with a lightning jab and seizes the prey in its long bill. It then flips the struggling meal about so that it can be smoothly swallowed head first. Birdwatchers might confuse the great blue heron with another large wader of similar color—the sandhill crane. This species can be distinguished by the big bustle of feathers on its rear (lacking in the great blue heron). In flight, the heron's neck is curled up, whereas the sandhill crane's neck is outstretched.

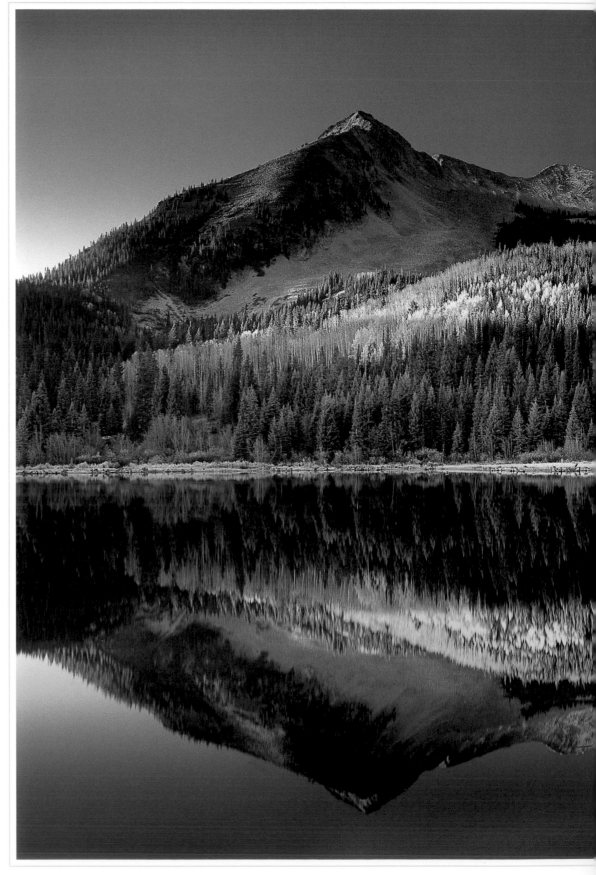

East Beckwith Mountain reflected in Lost Lake, Gunnison National Forest, Colorado.

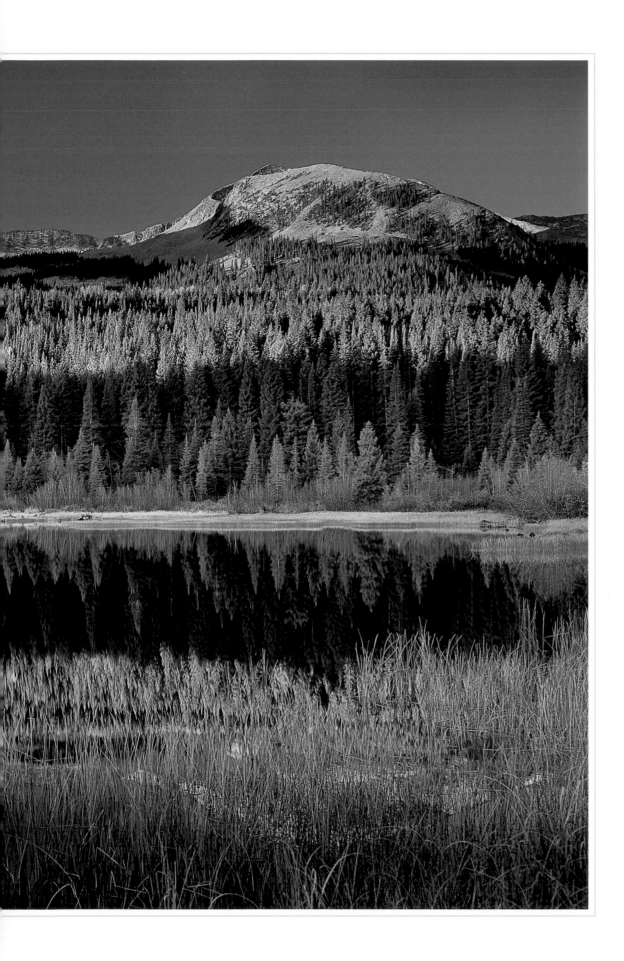

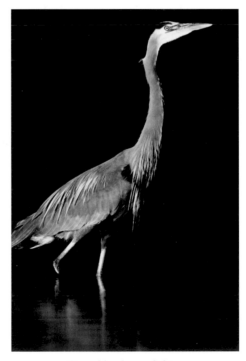

Great blue heron fishing.

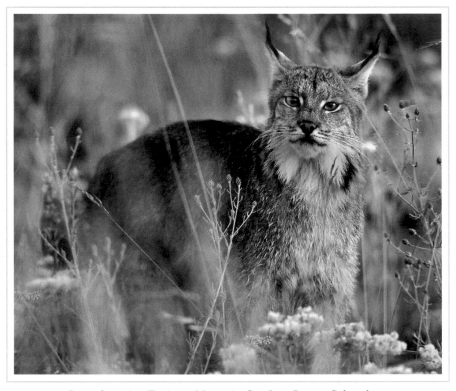

Lynx. Opposite: Engineer Mountain, San Juan Range, Colorado.

Sightings of the lynx, a medium-sized feline (length 3 ft./0.9 m), are rare due to its secretive, nocturnal habits. Dense, climax coniferous forests with concealing thickets and windfalls where the lynx's luxurious salt and pepper pelage blends with the gloom of vegetation are favored habitats. Adult lynx come together only during the breeding season in early spring. After a gestation period of two months, two to five kittens are born in a hollow log, small cave, or beneath a deadfall or in thick brush. The young remain with their mother until the end of their first winter.

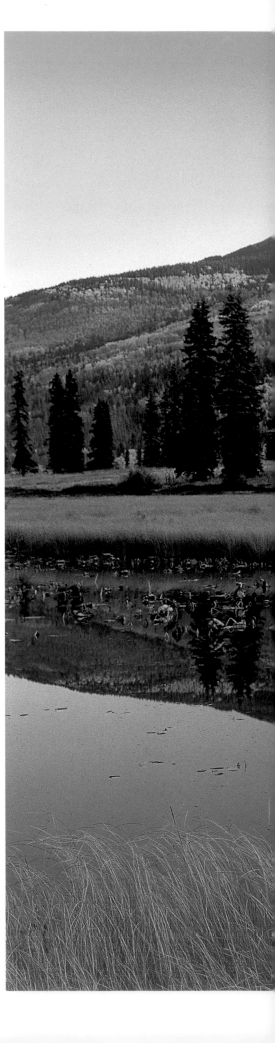

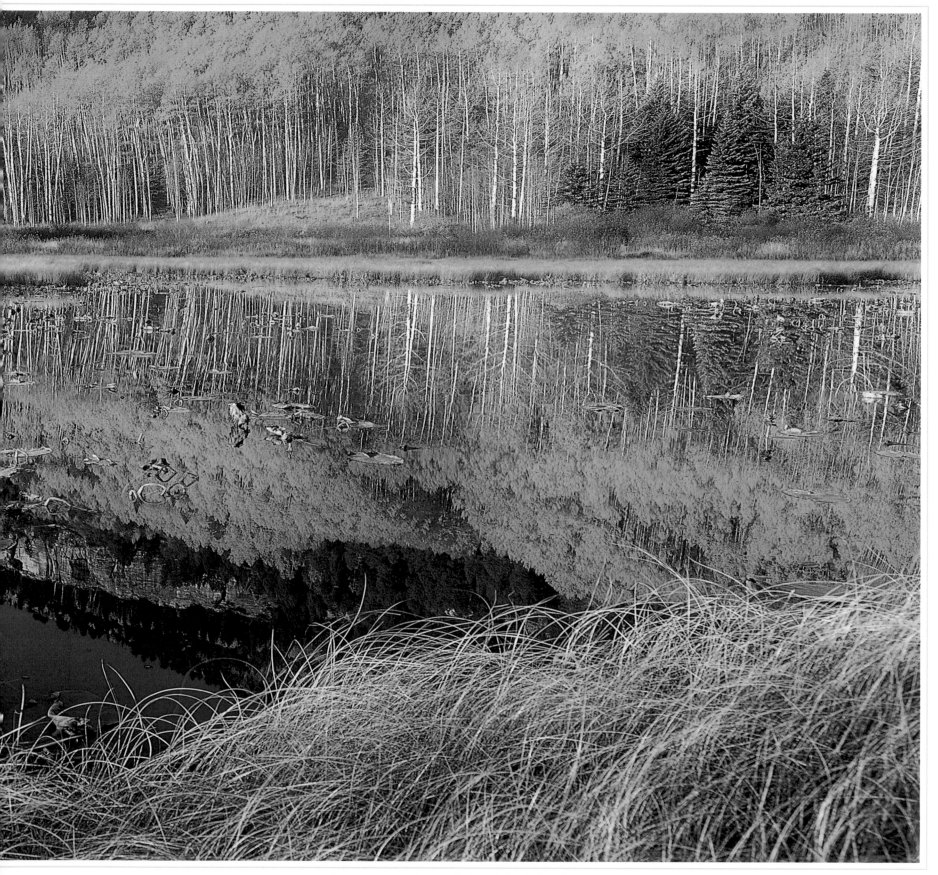

Autumn aspens, West Needle Mountains, Colorado.

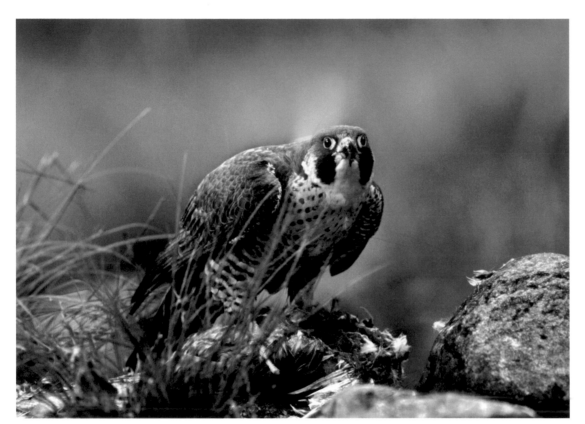

Peregrine falcon with duck.

A powerful, stream-lined raptor with long, pointed wings and tapered tail, the peregrine falcon is one of the swiftest fliers in the bird world. It kills ducks, pigeons, shore birds, upland game birds, and a variety of song birds, preferring to hunt in open country where it can dive on prey from above. Normally the falcon collides with the victim at great speed, talons bunched into fists, knocking it to the ground and following closely after to seize it in strong talons before it can recover. The falcon is commonly seen by birdwatchers throughout the Rocky Mountain region, identified by its swift flight, chunky profile, and affinity for wet habitats.

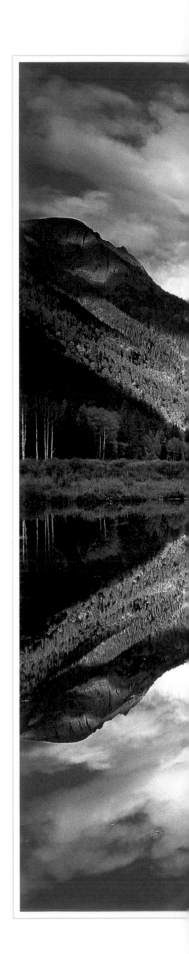

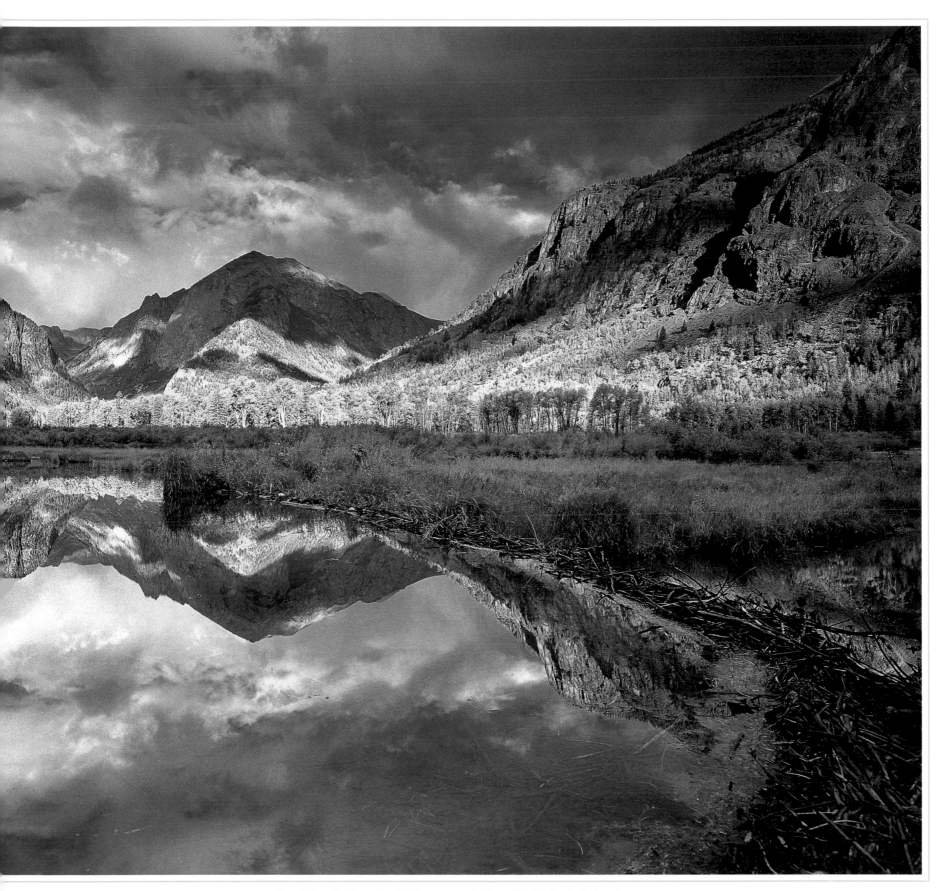

Greg Mace Peak reflected in beaver ponds along Castle Creek, Colorado.

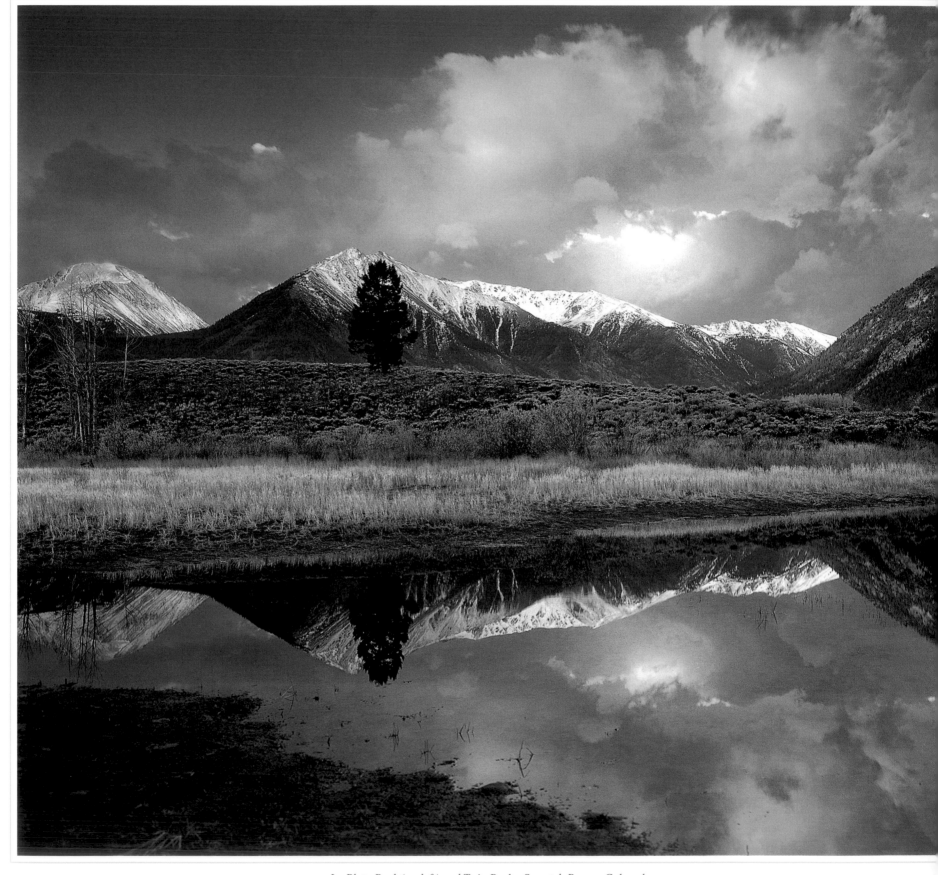

La Plata Peak (on left) and Twin Peaks, Sawatch Range, Colorado.

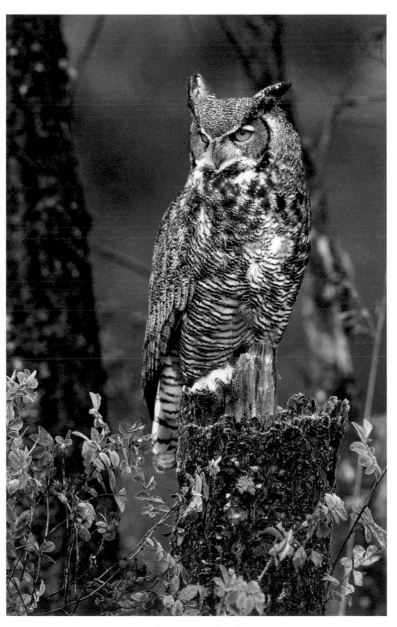

Great horned owl.

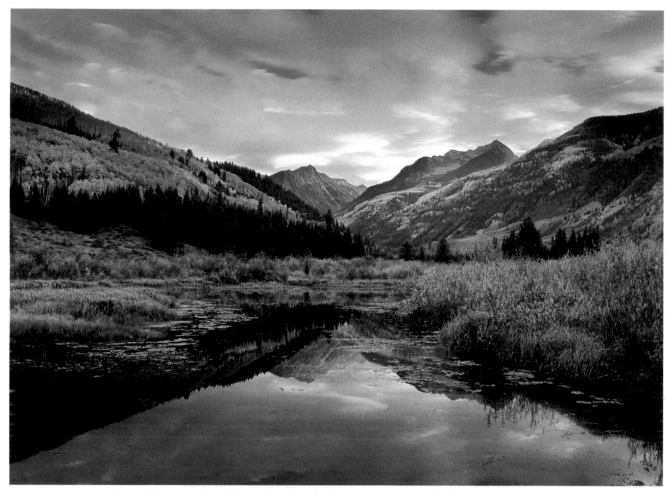

Ragged Peak and Chair Mountain reflected in beaver ponds along the Crystal River, Colorado.

Sporting a woolly, cream-colored coat, bighorn lambs are born in late May or early June. They stand about knee-height on long, trembling legs. For the first week they are hidden in dense brush or tall grass while the ewes are feeding. They gain strength quickly, however, and are soon following their mothers at a rapid pace, nursing frequently and nibbling tender shoots along the way. They are able to scramble nimbly over steep rock inclines at an early age. With the onset of their first winter, they are weaned and ready for life on their own.

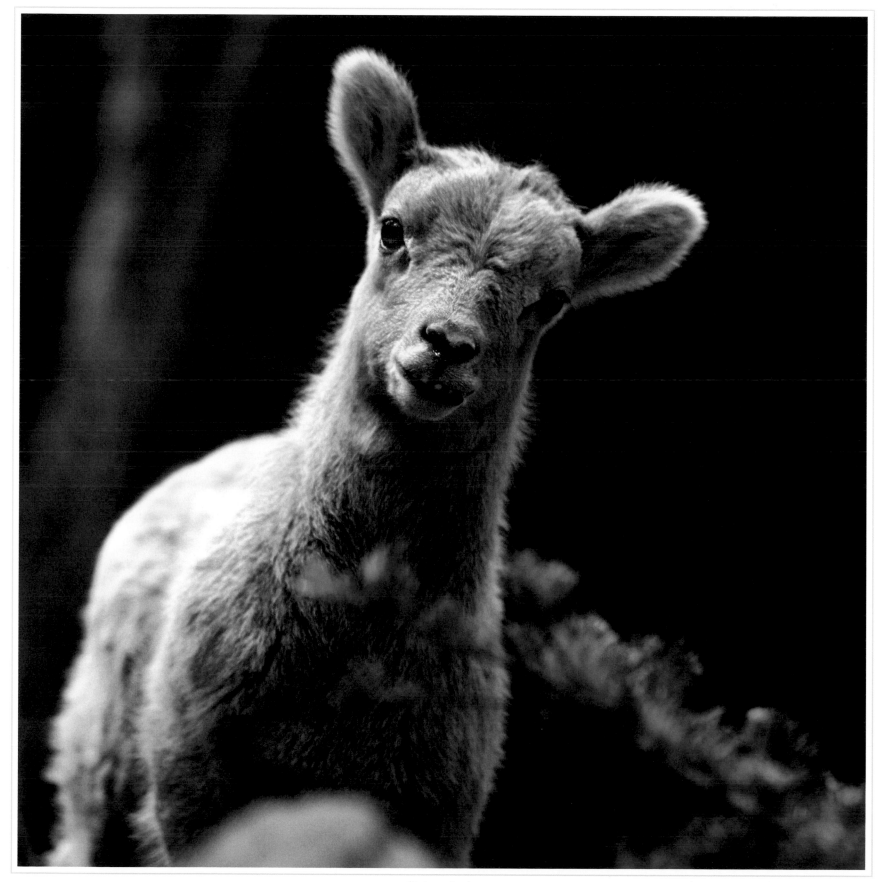

Bighorn lamb.

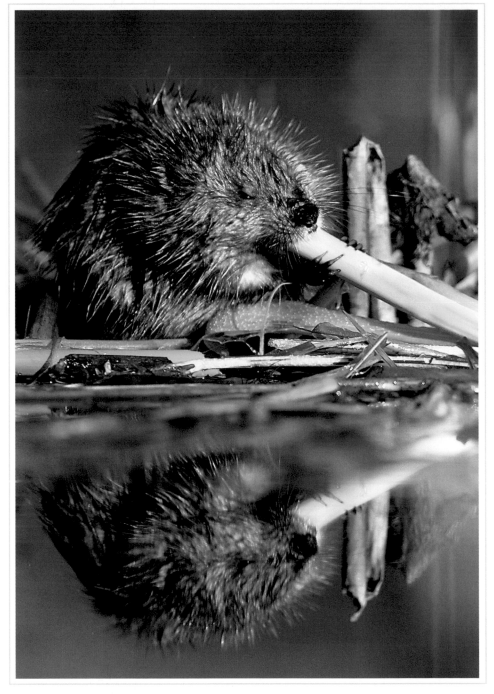

Muskrat eating bulrush tuber. Opposite: Mount Bellview, Gunnison National Forest, Colorado.

Muskrats are found throughout the Rocky Mountain region at mid and lower elevations wherever there is water. They frequent the marshy borders of lakes and rivers, feeding on pondweeds, sedges, and other emergent vegetation. Muskrats live in family groups, either in water lodges constructed of thatched aquatic plants or in bank burrows.

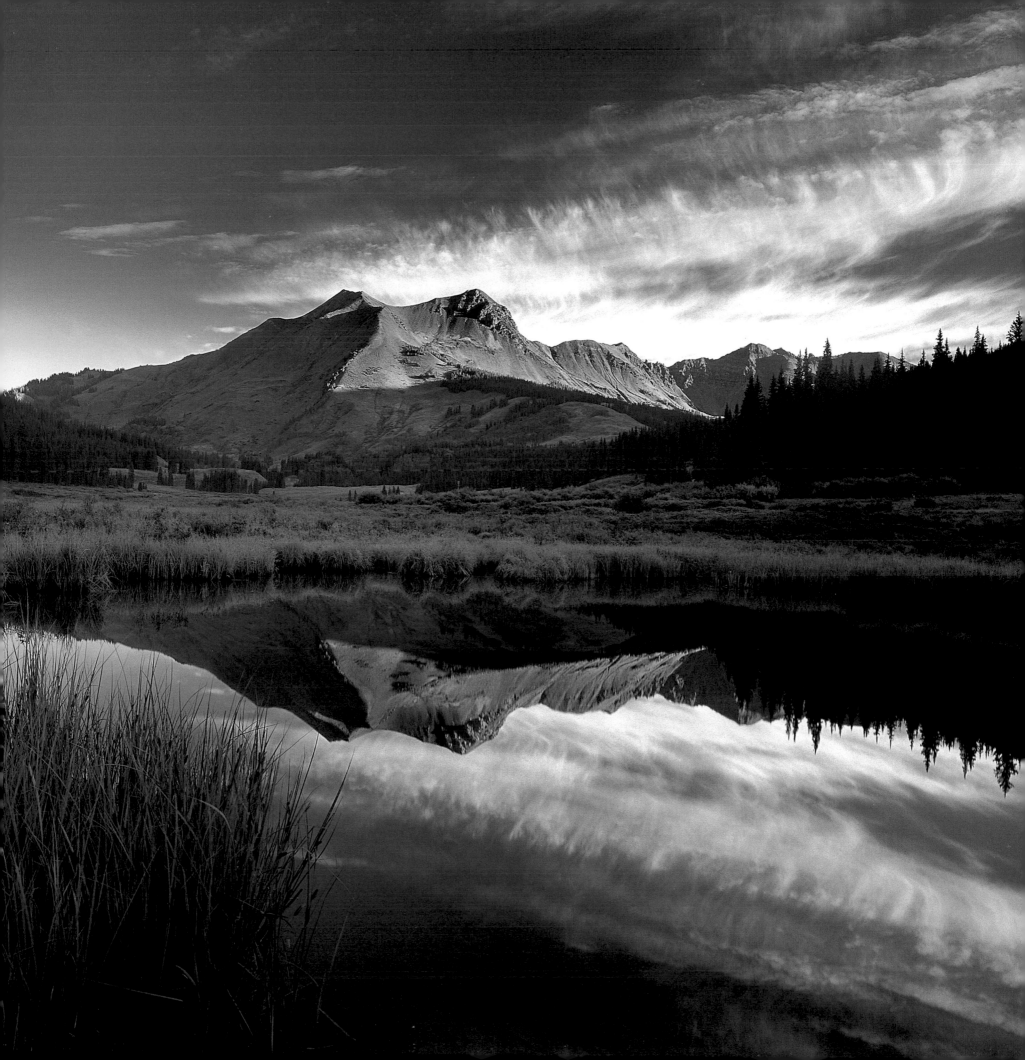

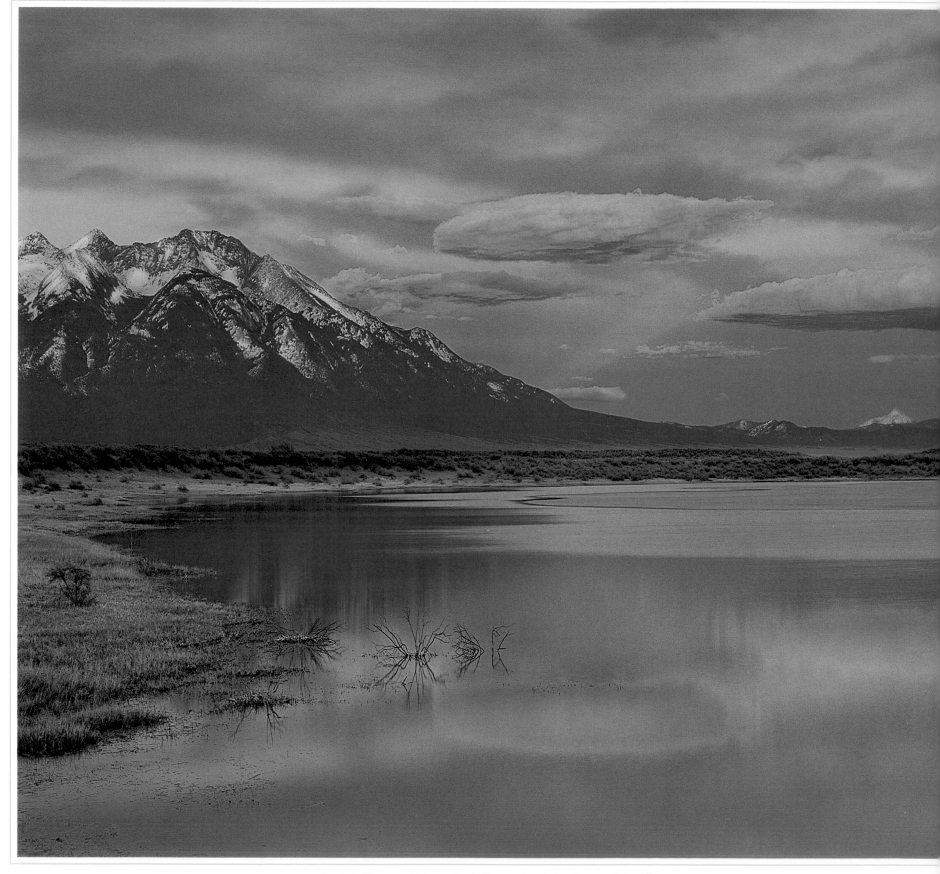

San Luis Valley and Blanca Peak, Sangre de Christo Range, Colorado.

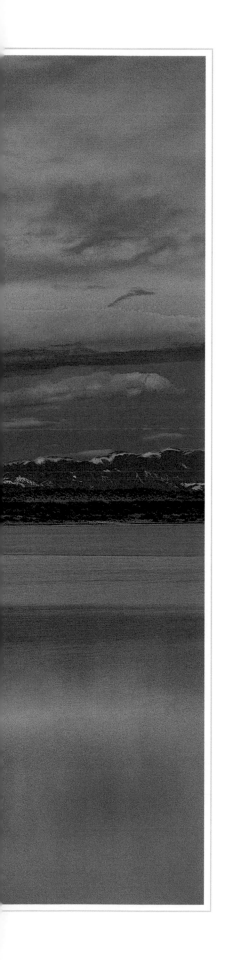

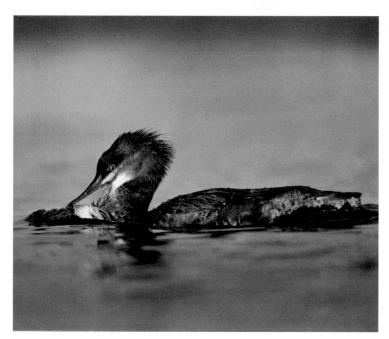

Common merganser with fish.

Over two ft. (0.6 m) long, the common merganser is seldom encountered away from water. Its most notable feature is a slim, red, hooked bill. Mergansers use their serrated bills to grasp slippery fish, which they often hunt cooperatively, lining up abreast to drive their prey through the shallows. Once a merganser snags a meal, it surfaces to adjust its hold on the prey—often thicker than the merganser's neck. This excites its fishing partners, which gather around in hopes of stealing the catch. Eventually the fish is swallowed by one of the flock and the lucky duck rests on the surface, digesting its meal and sipping water while the rest of the mergansers resume fishing.

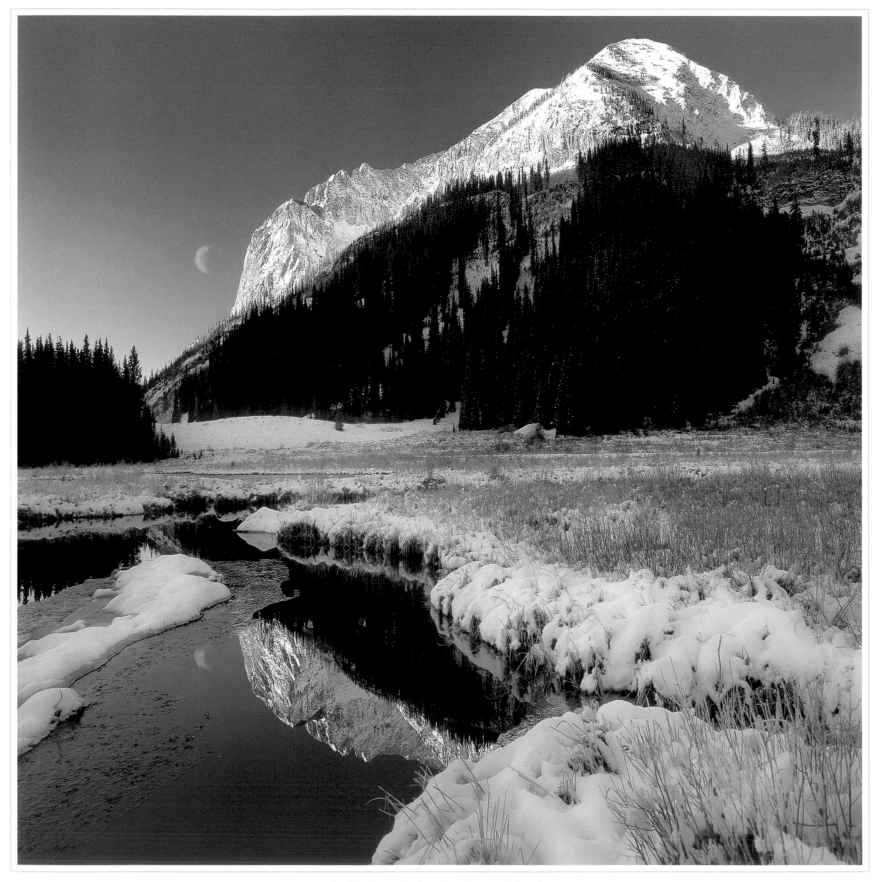

Gothic Mountain, San Juan Range, Colorado.

Aspens and blue spruce, Santa Fe National Forest, New Mexico.

A slender tree, the trembling aspen is common throughout the Rockies, preferring well-drained terrain. Its name is derived from the fine-toothed, long-stemmed leaves that quiver in the slightest breeze. The trunk is smooth, marked by dark, warty patches, and tinted in shades of cream, olive, tan, and gold. Strips of missing bark are usually a sign that elk have been browsing. Although aspens produce an abundance of buoyant, wind-propelled seeds, many groves develop from the spreading root systems of a single tree, which gives the stand a remarkably uniform appearance. Immense forests of pure aspen are common throughout the Colorado Rockies west of the front ranges.

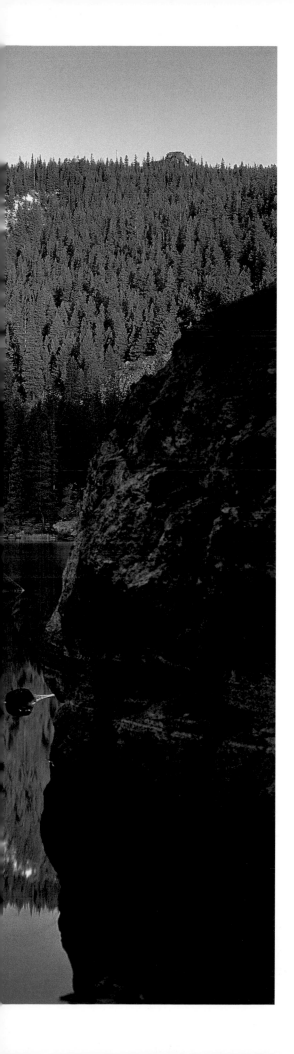

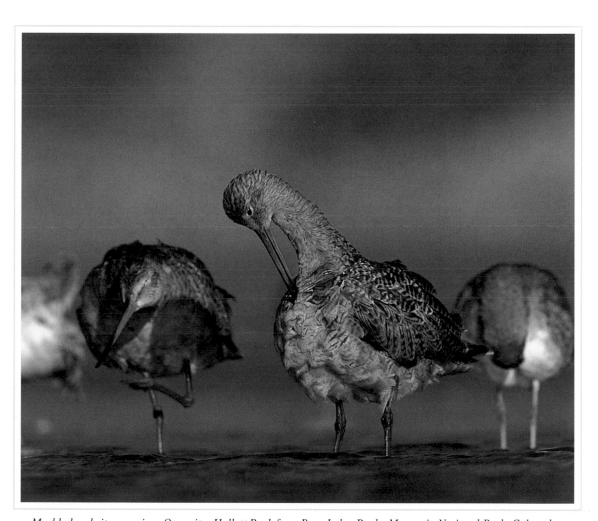

Marbled godwits preening. Opposite: Hallett Peak from Bear Lake, Rocky Mountain National Park, Colorado.

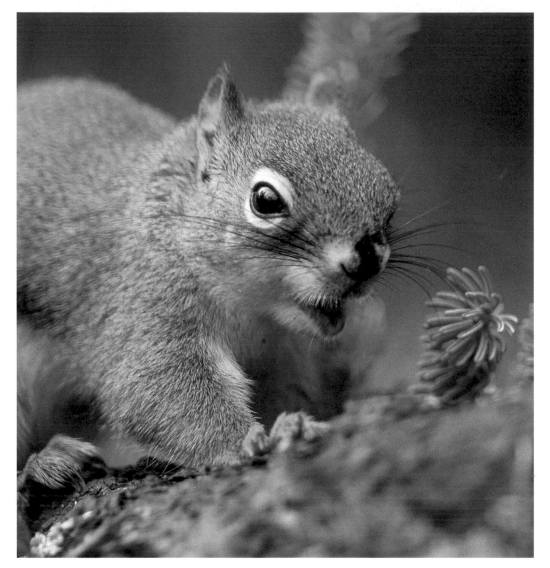

Red squirrel.

Bold and noisy, the red squirrel is the most common tree squirrel of the Rocky Mountain region. Active throughout the year, this rodent requires a lot of nutrition. In addition to a variety of fruits, nuts, seeds, and fungi, it eats insects, bird eggs, nestlings, mice, baby rabbits, and even adult birds when it can catch them. It drives sapsuckers and other woodpeckers away from tree trunks to feed from the holes they have bored. The mainstay of this little squirrel's diet, however, is conifer seeds plucked from cones. It amasses great piles of cones, often a yard deep and several yards across. The red squirrel defends its larder zealously by chattering, stamping its feet, twitching its bushy tail, and when the interloper is small enough, chasing it away.

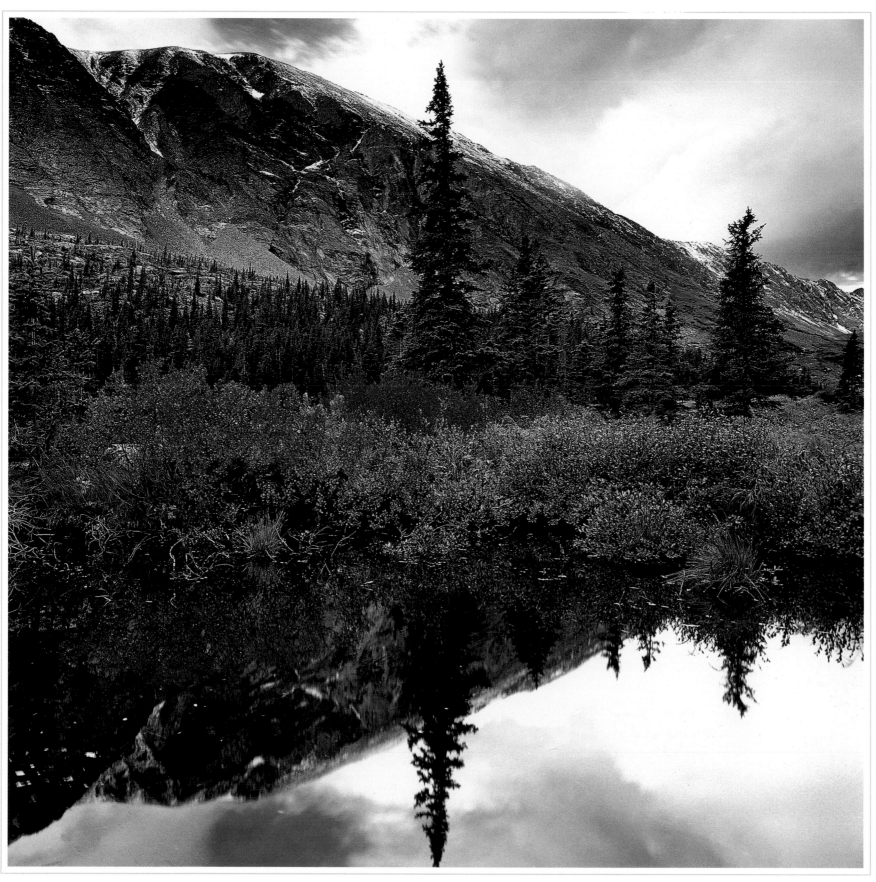

North Star Mountain, Mosquito Range, Colorado.

All of the wildlife photographs in this book were made with Canon cameras and lenses, principally the EOS A2, EOS 1NRS, and EOS 3. The lenses used were primarily those of telephoto focal length, specifically the 400mm f/2.8L, 500mm f/4.5 L, and the 35-350mm L. All of these were coupled frequently with the 1.4X Canon teleconverter. Normally I shot from a Bogan 3021 tripod equipped with a Kirk ball head adapted to accept Bogan quick-release plates. Although I used a variety of films, including the Kodak extra color emulsions, my preferred film, by far, was Fujichrome Velvia. Occasionally, I pushed this film one stop (to ISO 100) when low lighting conditions made this necessary.

Most of the bird photographs were taken from a low-profile, floating blind using the Canon 500mm f/4.5 L lens and a 1.4X teleconverter. This set-up was mounted on a Bogan Pro Art ball head fixed permanently to the blind. When shooting in this way, the camera is a mere 8" above the water surface, providing a dramatic, intimate shooting angle. The floating blind works well with all species of water birds, although ducks in the non-breeding season are difficult to approach. Muskrats sometimes tried to climb into the blind with me and blackbirds occasionally perched on top of it. Some Alberta farm boys once took long range potshots at me while in this blind, exotic

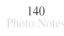

targets evidently being scarce in their neighborhood. Fortunately, they were not skillful.

The photographs of hoofed mammals were made in national parks, such as Yellowstone and Jasper, where the animals are accustomed to people and easier to approach for photography. In other areas, hunting pressure make such animals impossible to photograph dramatically and in detail. Squirrels, chipmunks, and picas were shot on their home territories, and attracted to specific sites (wildflower clumps usually) with peanut butter. The carnivores (wolf, bobcat, lynx, mountain lion) were born in captivity and photographed in natural Rocky Mountain habitats. Most were trained at the Triple D Game Farm near Kalispell, Montana, and the Wild Bunch Ranch near Driggs, Idaho. They were photographed while roaming about under the control of their trainer. There is no other way that I know of to photograph these species in the Rocky Mountain region.

For dangerous subjects, such as buffalo cows and elk bulls, I used a 500mm, or longer, lens and stayed close to a safe refuge, such as a tree or vehicle. In Jasper National Park, I was charged three times by a rutting elk when I inadvertently wandered between it and a cow. The bull chased me from one tree to another and then behind a large deadfall where we faced each other at arm's length, panting. At this

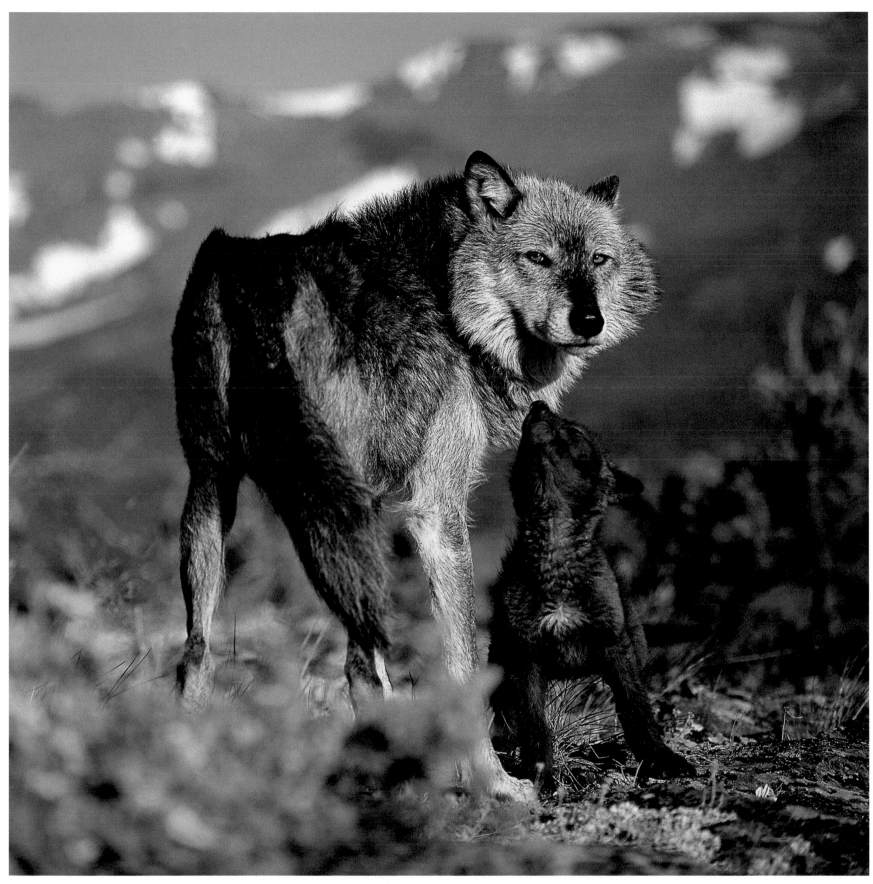

Timber wolf puppy and mother; Glacier National park in background.

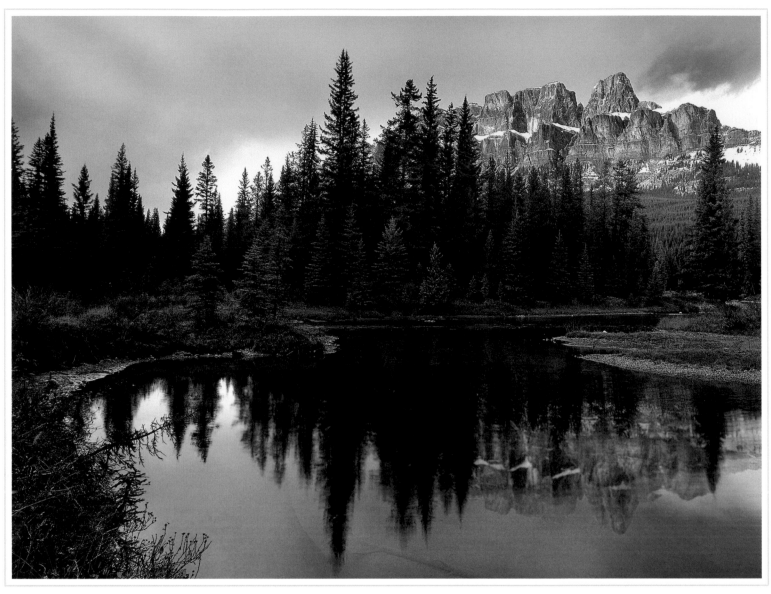

Castle Mountain, Banff National Patrk, Alberta.

juncture, I had opportunity to use pepper spray, which I carry for such emergencies, and drove the elk away. Buffalo cows can be just as dangerous, particularly young guard cows stationed on the periphery of the herd. Bears are always a hazard, but I seldom encountered them. In Waterton Lakes National Park, my wife, Joy, was approached by a small black bear, which I poked in the head with a tripod leg, causing it to leave. Normally bears are not deterred this easily.

With one exception (p. 40), the scenic photographs were made with Pentax 645 cameras equipped with lenses from 35mm to 300mm. The majority of the photographs were taken with a 45mm to 85mm f/4.5 zoom. This may not be the sharpest of lenses but for even poster-size reproduction, no reduction in quality can be discerned. The zooming feature allows precise framing of the composition and affords efficient use of the film area for maximum detail.

To help control contrast, I employed Singh-Ray graduated neutral density filters of +1, +2, or +3 stops, depending on the degree of contrast in the scene. To avoid vignetting, I attached these filters with duct tape rather than conventional filter holders, such as those made by Cokin. I used but one kind of film—Fujichrome Velvia—due to its natural, saturated color reproduction and fine grain.

Photographing reflections is best carried out from pre-dawn to early morning, the time when ponds and backwaters are most likely to be still and giving the clearest reflection. The most colorful scenes often occur before dawn when clouds are floating above the landscape. The oblique angle of light tints the clouds in rich hues of pink and orange. A camera positioned at right angles to the sun allows strong polarization (darkening) of the blue sky. Small, shallow pools (such as beaver ponds) are most likely to be still and will therefore throw the sharpest reflection. It's important to exercise patience in waiting for the wind to die. Small patches of water protected by a fallen log or rock are the best places to record detailed reflections when there is a breeze.

By wearing chest waders and carrying all of my equipment in a photography vest, I was able to set up the camera anywhere the water was less than waist deep. This made it possible to precisely position important foreground and mid-ground elements in the composition, which helped both define the scene's scale and provide a material

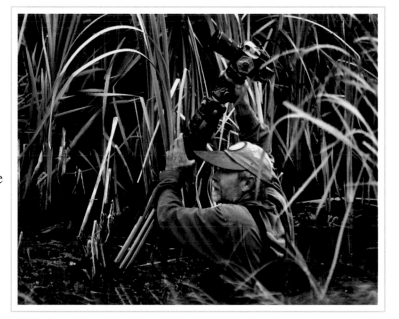

counterpoint to the reflection. I used topographic maps (1:200,000 on average) to help locate areas likely to have photogenic ponds and, as I usually did my scouting during midday, a compass to orient myself to the direction of the rising or setting sun. I almost always looked over a location the day before so that I knew exactly where to set up the tripod to record the best view the next dawn. Because of the amount of photo gear I carried and the necessity of wearing neoprene chest waders, I rarely hiked more than a mile or two to reach a shooting location. Most of the time I traveled only a few hundred meters from the road. Although you might think the most dramatic views are achieved by getting high and close, I found the opposite is generally true. When shooting at high elevations, less of the mountain is left to photograph, and at close range, the characteristic profile of the peak is lost or even obscured because the landscape plane is tilted more acutely away from the camera. Although I tried for more, I averaged about one good scenic photograph per day.

I traveled with my family in a small motor home which was instrumental in allowing me to wait comfortably for bad weather to abate, the sun to set, or cloud formations to modify. This vehicle was adapted for use on rough back roads generally suitable only for 4 x 4 travel. As you can imagine, this project provided an enjoyable way to spend a couple of summers.

PRODUCED BY TERRAPIN BOOKS
Santa Fe, New Mexico